Mrs. Wilkie

Out of the darkness and formless void came light, order—and man.

ADAM AND EVE: What did this innocent couple do so that God banished them from the Garden of Eden?

CAIN: Why did this murderer ask, "Am I my brother's keeper?"

ABRAHAM: For the sake of the one true God he would bring to his people, he agreed to kill his only son.

MOSES: Thousands of soldiers die—yet his people—just delivered from slavery—survive. What was his real power?

Here is the first in the unique series that brings all of the excitement, drama and color of the Bible in words and pictures from the world's greatest, truest Book!

The Picture Bible for All Ages

VOLUME 1

GENESIS 1:1-EXODUS 19:20

Script by Iva Hoth
Illustrations by Andre Le Blanc
Bible Editor, C. Elvan Olmstead, Ph.D.

CREATION

First printing, June 1973

(6) 1973 David C. Cook Publishing Co., Elgin, IL 60120
All Rights Reserved. This book, or parts thereof,
may not be reproduced in any form without permission
of the publisher, except by a reviewer who wishes
to quote brief passages in connection with a review
in a magazine or newspaper.
Published by David C. Cook Publishing Co.
Printed in United States of America by Offset Paperbacks.
Library of Congress Catalog Card Number: 73-78167
ISBN: 0-912692-13-8

ILLUSTRATED STORIES

In the Beginning	9
Temptation in the Garden	13
	16
The Verdict	19
When the Rains Came	22
The Great Flood	25
The Tower that Crumbled	29
Night Attack	33
Into the Unknown	36
A Tight Spot	39
	42
To the Rescue	46
A Stranger's Prophecy	49
	53
Test of Faith	57
Secret Mission to Haran	61
A Bride for Isaac	64
Cry of Revenge	69
Tricked	74
	79
	83
	86
_ N N N N N N N N N N N N N N N N N N N	90
	93
Slave Train to Egypt	96
The King's Dream1	
Trouble in Egypt19	
The Stolen Cup1	

Joseph's Secret112
South into Egypt116
Death Sentence120
Cry of a Slave124
The Fiery Bush128
Pharaoh's Revenge132
Plague of Death136
Гrapped141
Crossing the Sea145
Attacked149
The Mountain Trembles

Ciciru

In the beginning God created the heaven and the earth.

GENESIS 1: 1

IN THE BEGINNING

THERE WAS DARKNESS - DARKNESS AND SILENCE. GOD CREATED HEAVEN AND EARTH. HIS SPIRIT MOVED IST DAY THROUGH THE DARKNESS AND ACROSS THE WATERS. GOD SAID, "LET THERE BE LIGHT". AND THESE WAS LOSS. SAID, "LET THERE BE LIGHT": AND THERE WAS LIGHT. HOW BEAUTIFUL THE LIGHT WAS! THEN GOD DIVIDED THE LIGHT FROM THE DARKNESS AND CALLED THE LIGHT DAY AND THE DARKNESS NIGHT.

2nd DAY

GOD MADE THE SKY.
IN THE SKY HE PLACED CLOUDS
TO HOLD THE MOISTURE.
AND THE SKY WAS CALLED HEAVEN.

THEN GOD GATHERED TOGETHER THE
WATERS UNIDER THE SKY. HE CALLED
THESE "SEAS" AND HE NAMED THE
DRY LAND "EARTH." ON THE LAND HE
MADE GRASS AND FLOWERS AND
TREES, AND IN EACH WAS THE SEED
TO REPLENISH ITSELF. THE FRUITFUL
EARTH WAS TO
BECOME A PLACE
OF BEAUTY.

TO LIGHT THE EARTH,
GOD MADE THE SUN TO SHINE BY DAY, AND THE
MOON TO SHINE BY NIGHT...THE DAYS,
THE YEARS, AND THE SEASONS WERE ALSO SET
BY GOD. THEN HE MADE THE STARS
AND PLACED THEM IN THE HEAVENS.

5th DAY

GOD LOOKED UPON THE

LAND AND SEAS AND SAID:

"LET THE WATERS BRING FORTH
LIFE" — AND THE SEAS AND
RIVERS BECAME ALIVE WITH
WHALES AND FISH...

"LET THERE BE BIRDS" AND THE
OPEN SKY ABOVE THE EARTH
WAS FILLED WITH WINGED CREATURES.
"BE FRUITFUL AND MULTIPLY," GOD
SAID AS HE BLESSED THE LIVING
CREATURES OF THE SEA AND SKY.

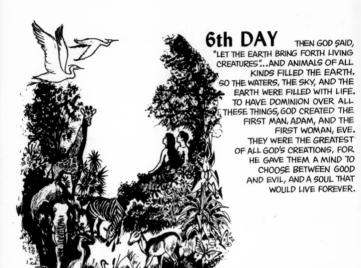

GOD TOOK ADAM AND EVE TO THE GARDEN OF EDEN AND SHOWED THEM THE BEAUTY AND FRUITFULNESS OF IT, AND GOD COMMANDED: OF EVERY TREE THOU MAYEST EAT FREELY...
BUT OF THE TREE OF KNOWLEDGE OF GOOD AND EVIL THOU MAYEST NOT EAT, FOR IN THE DAY THAT THOU EATEST OF IT THOU SHALT SURELY DIE...

AND ON THE SEVENTH DAY GOD RESTED...

OUR BIBLE IN PICTURES

Temptation in the Garden

FROM GENESIS 3

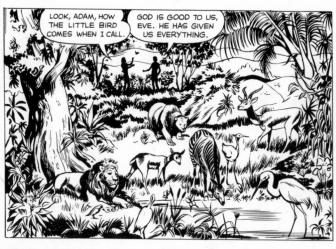

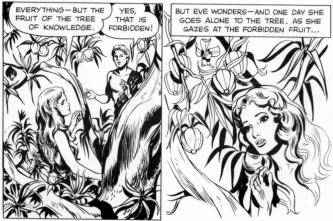

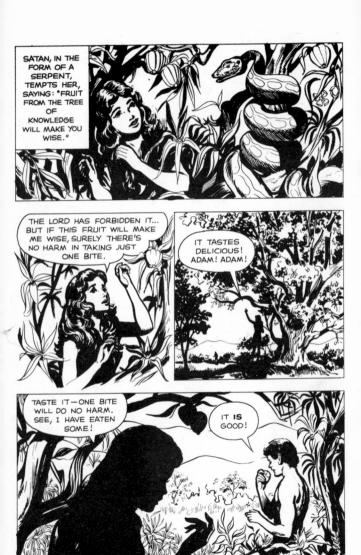

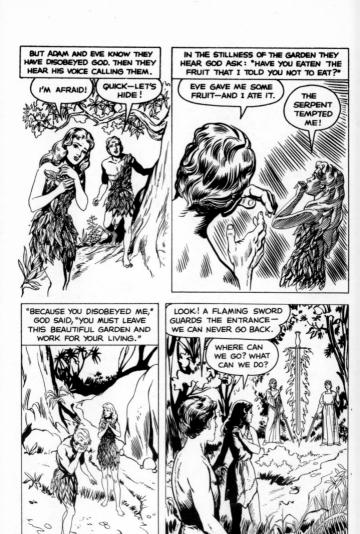

OUR BIBLE IN PICTURES

Jealous Brothers

FROM GENESIS 4: 1-8

OUTSIDE THE GARDEN OF EDEN THE LAND IS BARREN, HOT AND DRY. WEARY, ALONE AND FRIGHTENED, ADAM AND EVE SEARCH UNTIL THEY FIND A PLACE TO MAKE A HOME.

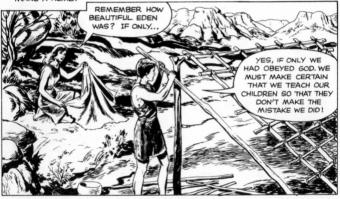

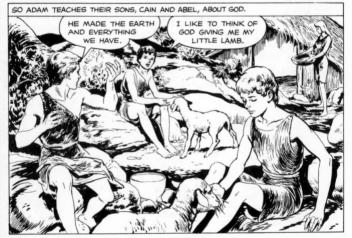

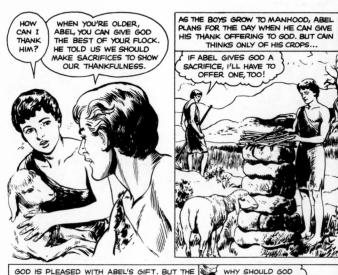

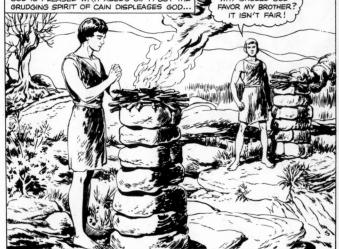

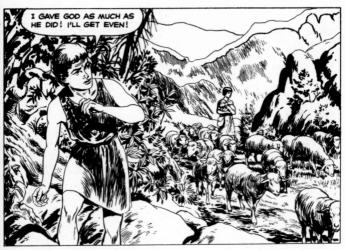

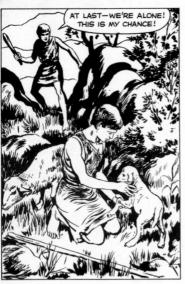

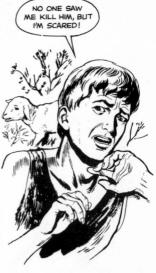

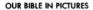

The Verdict

FROM GENESIS 4: 8-26; 5; 6: 1-8 IN A LONELY PASTURE, CAIN KILLED HIS BROTHER, ABEL, CAIN IS SURE NOBODY SAW THE MURDER. BUT SUDDENLY THE KILLER IS AFRAID ... DID SOMEONE SEE HIM? WHO?

HE LOOKS AROUND ... AND THEN HE HEARS THE VOICE OF GOD ASKING: "WHERE IS ABEL, YOUR BROTHER?"

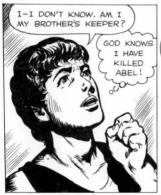

TERRIFIED, CAIN HEARS GOD'S VERDICT-AS PUNISHMENT FOR MURDERING ABEL, CAIN MUST LEAVE HOME AND FOREVER BE A FUGITIVE.

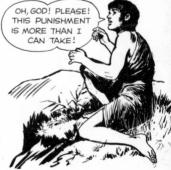

AND METHUSELAH WHO DIED AT THE AGE OF 969—THE OLDEST MAN WHO EVER LIVED.

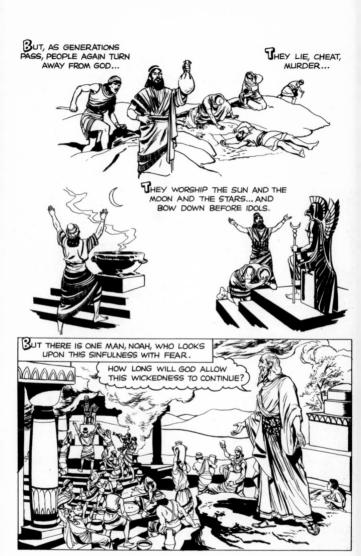

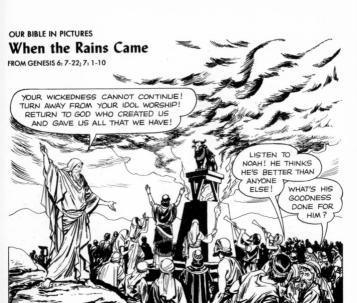

BUT NOAH REMAINS TRUE TO GOD.
AND ONE DAY GOD SPEAKS TO HIM:
"THE EARTH IS FILLED WITH VIOLENCE....I
WILL DESTROY MAN WHOM I HAVE
CREATED. MAKE THEE AN ARK, FOR
BEHOLD I WILL BRING A FLOOD OF
WATERS UPON THE EARTH."

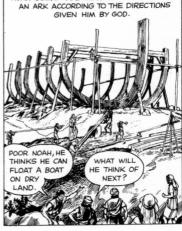

NOAH OBEYS-AND SETS TO WORK BUILDING

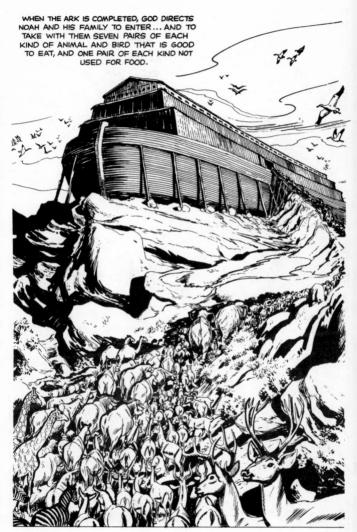

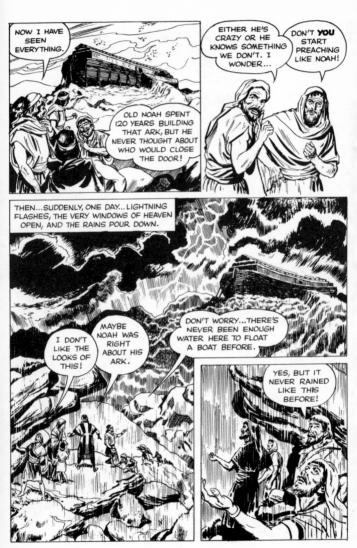

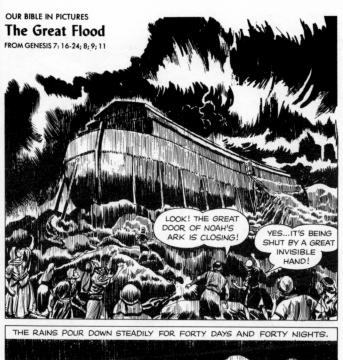

THE RAINS POUR DOWN STEADILY FOR FORTY DAYS AND FORTY NIGHTS.

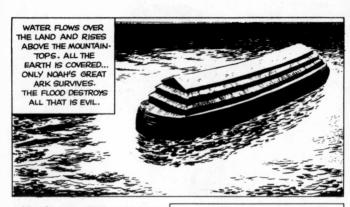

AT LAST THE WATER LEVEL DROPS AND THE ARK RESTS ON THE TOP OF THE MOUNTAINS OF ARARAT.

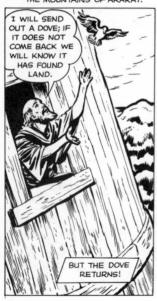

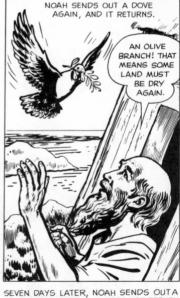

SEVEN DAYS LATER, NOAH SENDS OUT A DOVE A THIRD TIME. IT DOES NOT RETURN BECAUSE IT HAS FOUND A PLACE TO NEST.

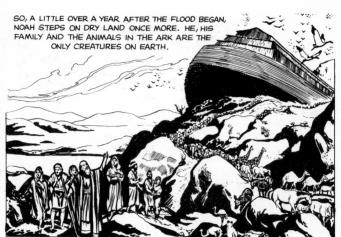

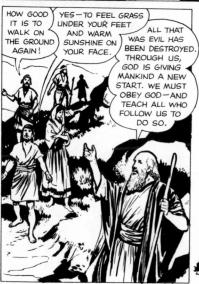

AS SOON AS NOAH LEAVES THE ARK, HE BUILDS AN ALTAR. HERE HE THANKS GOD FOR HIS CARE AND ASKS GOD'S GUIDANCE IN HELPING NOAH AND HIS FAMILY TO MAKE A NEW START. THEN GOD MAKES A PROMISE TO NOAH AND TO ALL HIS CHILDREN, FOREVER...

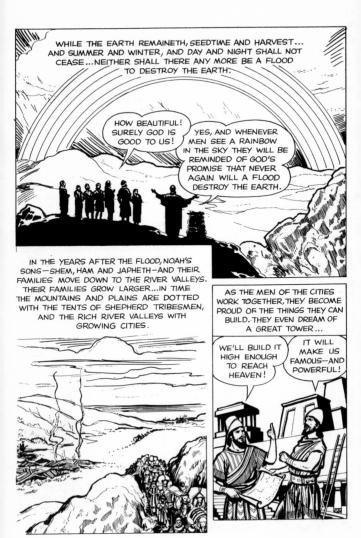

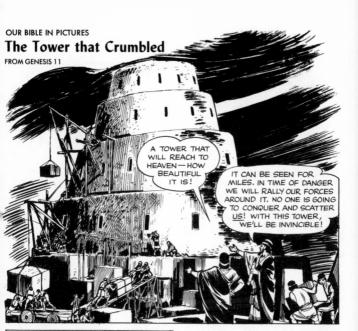

BUT GOD IS DISPLEASED WITH THE PEOPLE'S DESIRE FOR FAME AND POWER. TO STOP THEIR WORK ON THE TOWER, HE CAUSES THE PEOPLE TO SPEAK IN DIFFERENT LANGUAGES.

BECAUSE THEY CANNOT UNDERSTAND ONE ANOTHER, THE BUILDERS ARE CONFUSED. THEY STOP WORKING ON THE TOWER. ONE BY ONE, THE FAMILIES WHO SPEAK THE SAME LANGUAGE MOVE AWAY. THE GIANT TOWER, CALLED BABEL, BEGINS TO CRUMBLE...

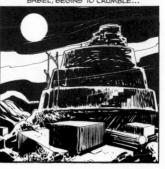

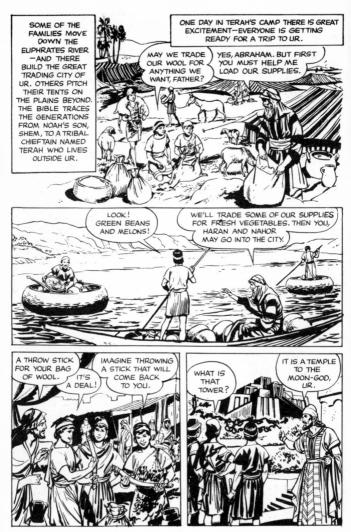

BACK HOME, ABRAHAM THINKS OFTEN ABOUT HIS VISIT TO UR. AND AS HE GROWS OLDER HE WONDERS ABOUT THE TEMPLE OF THE MOON-GOD.

ONE EVENING ABRAHAM TALKS TO SARAH, THE MOST BEALITIFUL GIRL IN HIS FATHER'S CAMP.

IT'S ONLY THE MOON, SARAH, NOT SOMETHING TO WORSHIP.

ONE SHIP.

ABRAHAM—BE CAREFUL. MANY PEOPLE HERE WORSHIP THE MOON-GOD. THEY MIGHT HEAR YOU AND DO YOU HARM.

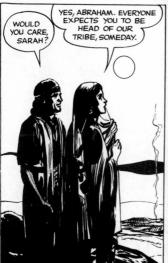

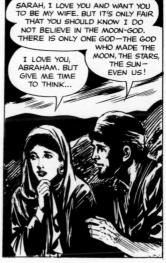

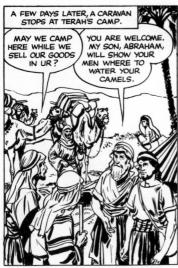

IT IS A FESTIVE DAY FOR ALL OF THE TRIBE WHEN ABRAHAM AND SARAH ARE MARRIED. DURING THE CEREMONY SARAH PRAYS TO GOD, ASKING FOR COURAGE TO STAND BY HER HUSBAND—FOR THEY ARE TWO AGAINST MANY WHO BELIEVE

SO YOU COME NO, THEY HAVE FROM CANAAN. THEIR OWN GODS DO THE PEOPLE CALLED BAALS. THERE WORSHIP THE MOON-GOD, UR? DO YOU, SARAH? BAAL! THE MOON-GOD! EVERY THEN WE'LL BOTH TRUST IN ONE HAS A DIFFERENT GOD. GOD-NO MATTER WHAT ABRAHAM, I BELIEVE AS YOU DO-THERE HAPPENS. IS ONLY ONE GOD.

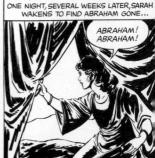

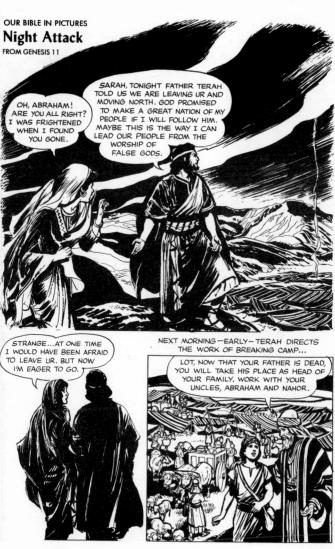

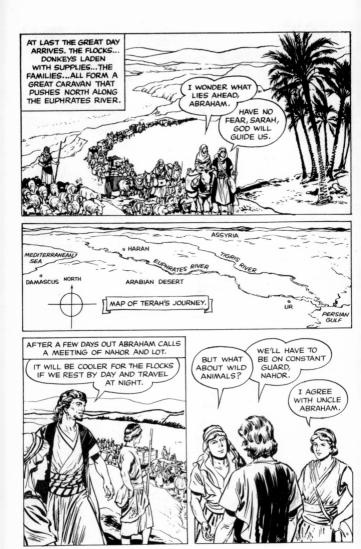

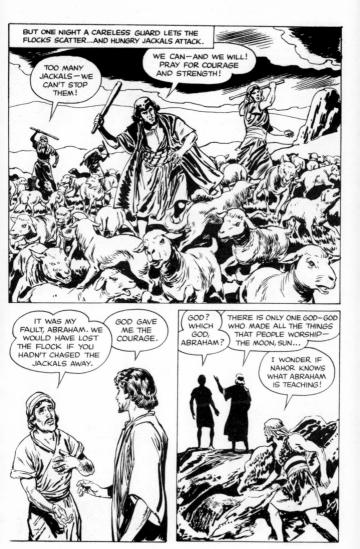

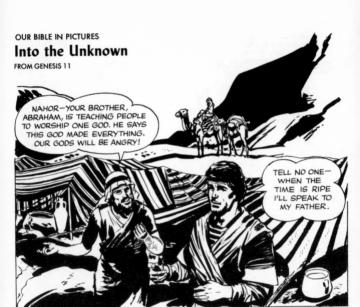

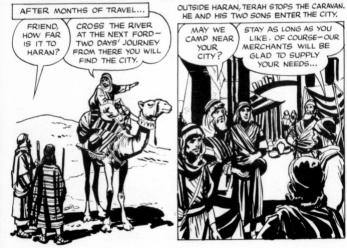

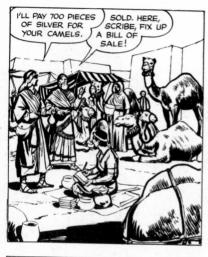

ABRAHAM WEIGHS OUT THE SILVER. SOON HE IS RAISING HIS OWN HERDS AND FLOCKS.

ALL GOES WELL IN TERAH'S CAMP UNTIL ONE DAY WORD SPREADS THROUGHOUT THE TENTS—TERAH IS ILL!

THIS IS THE TIME TO L TELL YOUR FATHER ABOUT ABRAHAM'S GOD BEFORE ABRAHAM BECOMES CHIEF! NO, MY FATHER IS TOO ILL.

THAT NIGHT TERAH, THE OLD CHIEFTAIN, DIES. GRIEF-STRICKEN, HIS SONS LEAVE THE TENT OF THEIR FATHER...

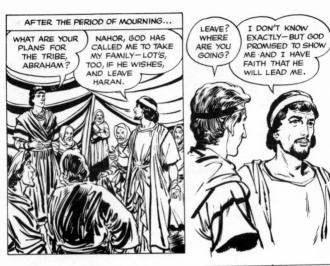

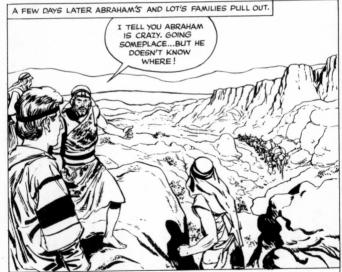

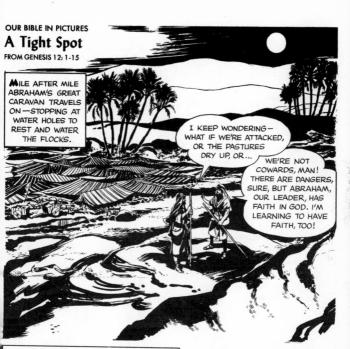

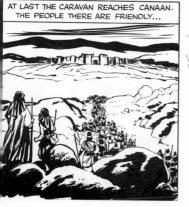

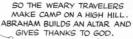

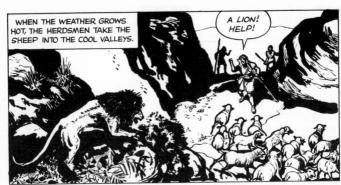

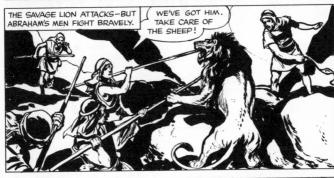

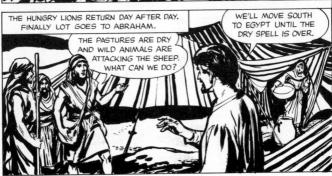

SO ONCE AGAIN THE TENTS ARE TAKEN DOWN, CLOTHING PACKED AND THE ANIMALS ROUNDED UP FOR THE MOVE SOUTH.

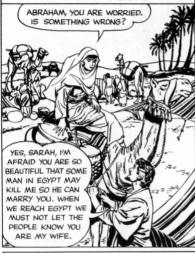

KILL YOU! OH,
ABRAHAM, I'LL DO
ANYTHING YOU
ASK!

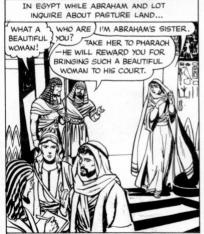

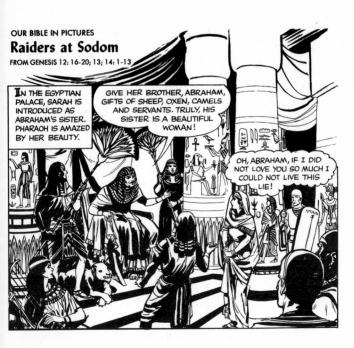

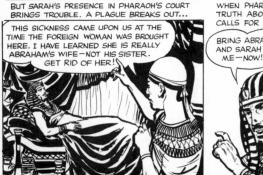

WHEN PHARAOH LEARNS THE TRUTH ABOUT SARAH, HE CALLS FOR HIS SOLDIERS.

BRING ABRAHAM AND SARAH TO

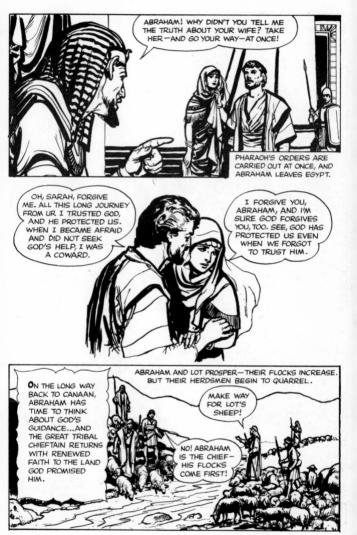

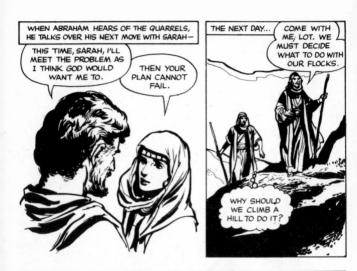

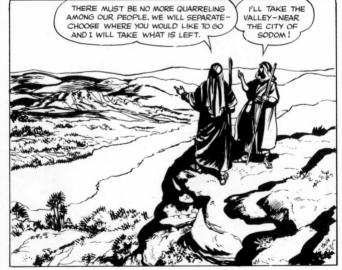

AFTER LOT LEAVES, GOD SPEAKS TO ABRAHAM: "ALL THE LAND WHICH THOU SEEST, TO THEE WILL I GIVE IT, AND TO THY SEED FOR EVER." TRUSTING IN GOD, ABRAHAM MOVES TO HEBRON, AND THERE BUILDS AN ALTAR TO WORSHIP GOD. NEIGHBORING CHIEFTAINS LEARN TO RESPECT ABRAHAM, AND ONE DAY THEY SEEK HIS HELP...

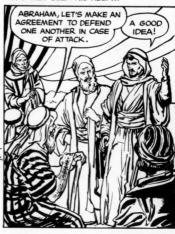

NOT LONG AFTER, THE WHOLE CAMP IS SURPRISED BY A MESSENGER WHO RACES IN DEMANDING TO SEE ABRAHAM.

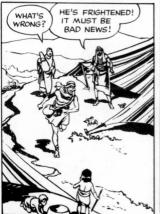

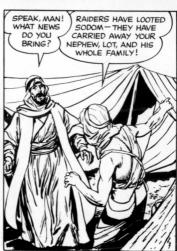

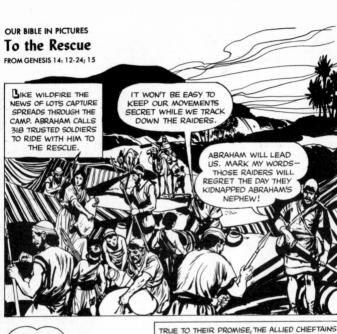

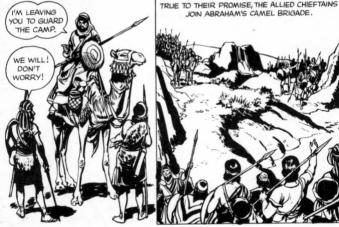

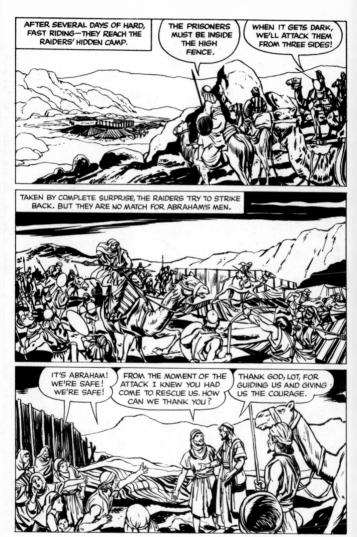

BACK HOME THE TRIUMPHANT WARRIORS ARE GIVEN A JOYOUS RECEPTION. BUT ABRAHAM IS DISTURBED BECAUSE SARAH TAKES NO PART IN THE CELEBRATION.

OH, ABRAHAM, WHEN YOU LEFT THE CAMP IN CHARGE OF THE YOUNG MEN, IT OPENED AN OLD ACHE IN MY HEART. WE HAVE NO SON NO SON TO GUARD THE CAMP WHILE YOU ARE GONE. NO SON TO RIDE WITH YOU.

KNOW, SARAH. GOD HAS PROMISED THAT I SHALL BE THE FATHER OF A GREAT NATION, YET I HAVE NO HEIR.

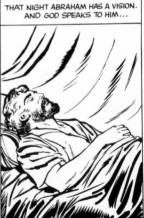

OUR BIBLE IN PICTURES

A Stranger's Prophecy

FROM GENESIS 16; 17; 18; 19: 1-10

ABRAHAM IS DISTURBED. GOD HAS PROMISED THAT HE WILL BE THE FATHER OF A GREAT NATION, YET HE HAS NO SON THROUGH WHOM THIS NATION CAN BE BUILT. ONE NIGHT ABRAHAM HAS A VISION AND ONCE AGAIN GOD SPEAKS TO HIM: "LOOK TOWARD HEAVEN, AND COUNT THE STARS, IF THOU BE ABLE TO NUMBER THEM ... SO SHALL THE NUMBER OF THY DESCENDANTS BE."

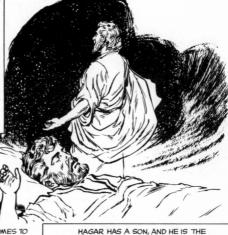

LATER, WHEN SARAH COMES TO HIM WITH A PLAN, HE LISTENS...

BY THE CUSTOM OF OUR PEOPLE I CAN GIVE YOU HAGAR, MY HANDMAID, AS A WIFE THAT SHE MIGHT HAVE A SON FOR ME. GOD HAS PROMISED ME AN HEIR-PERHAPS THIS IS RIGHT...

PRIDE OF ABRAHAM'S HEART.

MY ISHMAEL IS A PROUD AND DARING ONE!

REMEMBER, HAGAR, HE IS MY SON! I ADOPTED HIM!

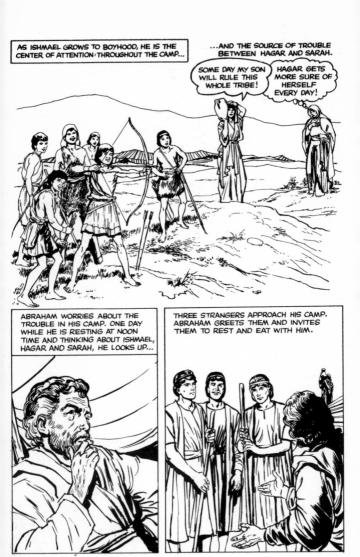

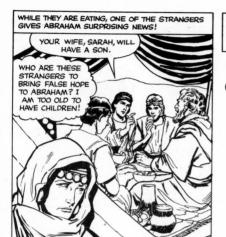

BUT SARAH IS NOT THE ONLY ONE WHO OVERHEARS THE NEWS, HAGAR ALSO LISTENS AND IS AFRAID...

IF SARAH HAS
A SON, WHAT WILL
HAPPEN TO ISHMAEL
-AND ME!

WHEN THE STRANGERS LEAVE, ABRAHAM WALKS A WAY WITH THEM.

WALKS A WAY WITH THEM.

THAT CITY OF SODOM
IS SO WICKED THAT
GOD MAY HAVE TO
DESTROY IT.

THE PLACE LOT
LIVES!

ABRAHAM PRAYS FOR SODOM, AND GOD PROMISES THAT THE CITY WILL BE SAVED IF THERE ARE TEN GOOD MEN IN IT.

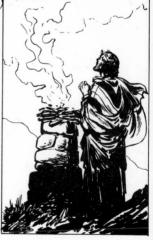

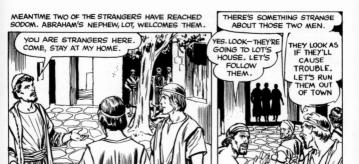

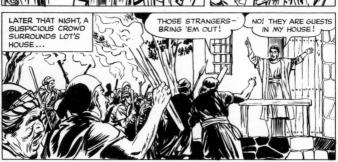

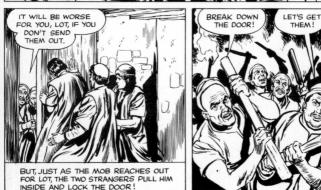

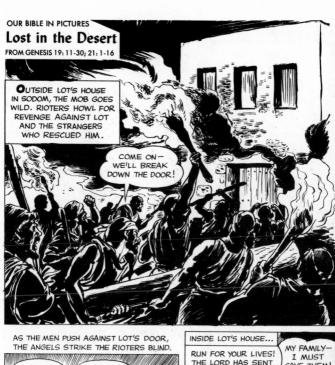

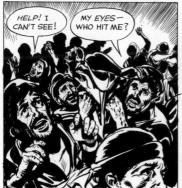

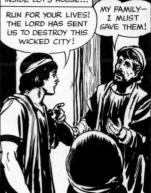

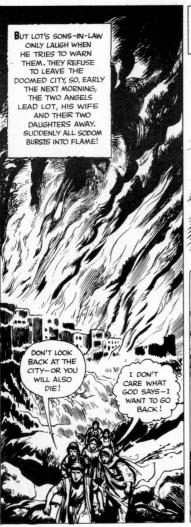

LOT'S WIFE STOPS...LOOKS BACK LONGINGLY... AND IS TURNED INTO A PILLAR OF SALT...SO ONLY LOT AND HIS TWO DAUGHTERS ESCAPE GOD'S PUNISHMENT.

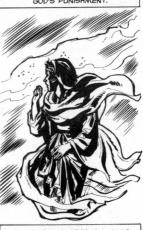

NEXT MORNING, ABRAHAM GOES TO THE HILLTOP TO WORSHIP-AND SEES THE SMOULDERING RUINS OF THE WICKED CITY...

AS SURELY AS NIGHT FOLLOWS DAY, DESTRUCTION FOLLOWS SIN. O GOD, HELP ME TO LEAD MY PEOPLE IN THE PATHS OF RIGHTEOLISNESS!

EAGER TO LEAVE THE RUINS OF SODOM, ABRAHAM MOVES TO BEER-SHEBA, NEAR THE DESERT. HERE, SARAH'S SON IS BORN.

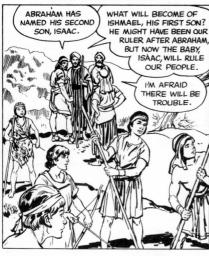

SARAH AND HAGAR BECOME MORE JEALOUS DAY BY DAY. THEN AT THE BABY ISAAC'S FIRST FEAST...

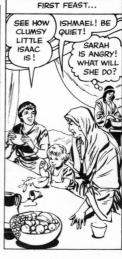

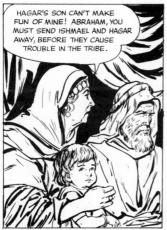

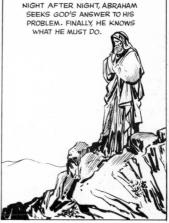

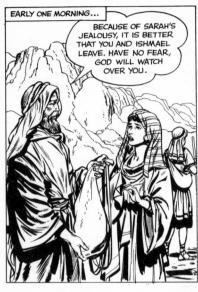

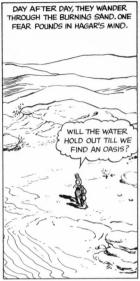

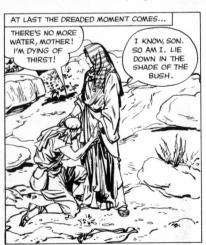

O GOD, LET ME

NOT SEE THE DEATH

Test of Faith

FROM GENESIS 21: 17-21; 22: 1-10

DEAD TIRED AND CHOKING WITH THIRST, HAGAR TURNS HER BACK ON HER SON, ISHMAEL ... SHE CANNOT WATCH HIM DYING. SUDDENLY SHE HEARS A VOICE. IT'S GOD SAYING: "LIFT UP THE LAD, FOR I WILL MAKE HIM A GREAT NATION".

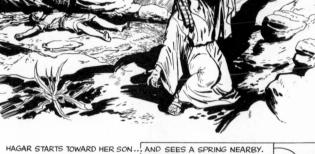

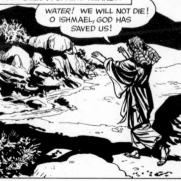

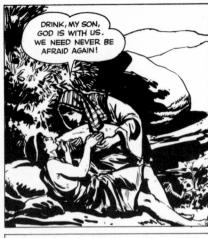

KNOWING GOD IS
WITH THEM, HAGAR AND
ISHMAEL CONTINUE
THEIR JOURNEY TO A
PLACE IN THE
WILDERNESS WHERE
THEY BUILD A HOME.
YEARS PASS—ISHMAEL
MARRIES AN EGYPTIAN
GIRL AND BECOMES
THE HEAD OF A GREAT
DESERT TRIBE.

IN ABRAHAM'S CAMP, THE YEARS PASS SWIFTLY, TOO. YOUNG ISAAC PROVES HIMSELF A WORTHY SON OF THE TRIBE'S GREAT LEADER.

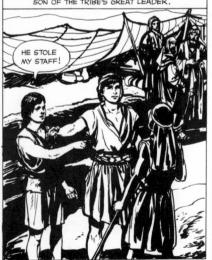

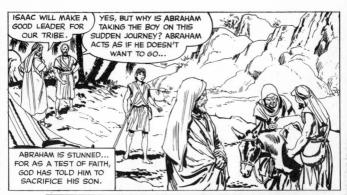

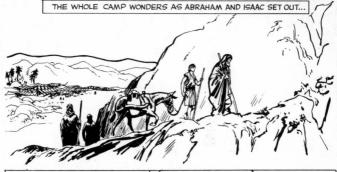

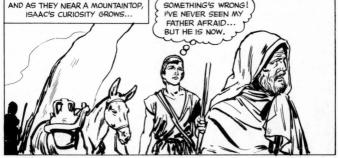

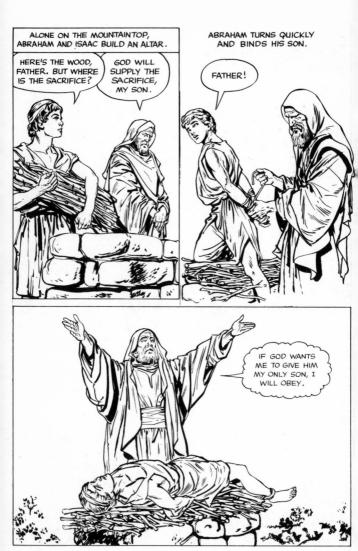

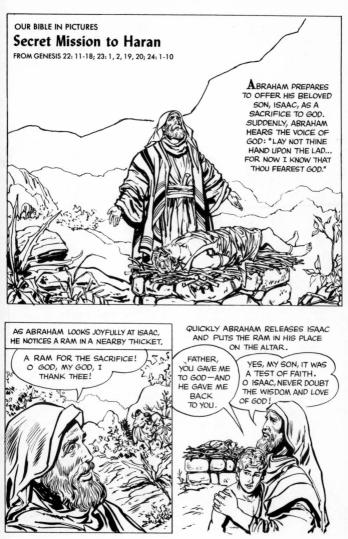

WITH JOYOUS HEARTS, ABRAHAM AND ISAAC GIVE THANKS TO GOD. AND ABRAHAM HEARS GOD'S PROMISE: "THROUGH YOU, ALL NATIONS

ON THE WAY HOME, ISAAC WALKS AHEAD—AND ALONE. THROUGH HIS MIND FLASH SCENES OF THE DAY. HE CAN STILL FEEL THE ROPES THAT TIED HIM ON THE ALTAR...SEE HIS FATHER'S DAGGER...FEEL THE JOY OF KNOWING HE WOULD NOT BE KILLED.

SARAH RUSHES OUT OF THE CAMP TO GREET THEM.

ISAAC, MY SON, WHAT HAPPENED? YOU LEFT HERE A BOY-YOU HAVE RETURNED A MAN— LIKE YOUR FATHER, STRONG, TALL, WISE. FROM MY FATHER
I LEARNED THE
COST OF FAITH...
AND FROM GOD,
THE REWARD.

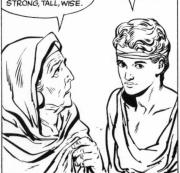

IN THE YEARS THAT FOLLOW, THE TRIBE OF ABRAHAM PROSPERS, THEN ONE DAY, SAD NEWS SPREADS THROUGHOUT THE CAMP...SARAH IS VERY SICK.

ONE EVENING, ABRAHAM APPEARS AT THE DOOR OF HIS TENT ... THE CAMP GROWS QUIET. AND LIKE A MAN IN A DREAM, HE TELLS HIS PEOPLE, SARAH, HIS WIFE, IS DEAD.

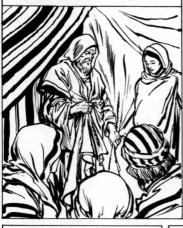

SARAH IS BURIED IN A CAVE AT MACHPELAH, AND THE WHOLE TRIBE MOURNS HER DEATH.

ISAAC IS GOING IT IS WELL. HE ALONE INTO THE MUST CONQUER WILDERNESS TO HIS GRIEF. MOURN FOR HIS MOTHER.

ONE DAY, ABRAHAM CALLS HIS MOST TRUSTED SERVANT TO HIM.

BEFORE I DIE, I WANT TO SEE MY SON HAPPILY MARRIED TO A WOMAN OF MY OWN PEOPLE. GO TO HARAN AND BRING BACK A WIFE FOR ISAAC.

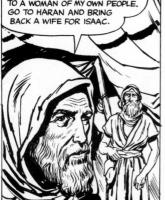

ABRAHAM'S SERVANT GATHERS A LONG CARAVAN. HE LEADS IT ACROSS THE DESERT AND FINALLY REACHES THE CITY OF HARAN. WHERE ABRAHAM'S RELATIVES LIVE.

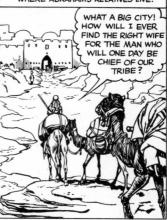

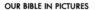

A Bride for Isaac

FROM GENESIS 24: 11-67; 25: 7, 8

ABRAHAM'S SERVANT REACHES HARAN IN THE EVENING.
HE RESTS BY THE TOWN'S WELL AND SEES YOUNG WOMEN
OF THE CITY COMING TO GET WATER.

O GOD, GIVE ME A SIGN! LET
THE ONE WHO GIVES WATER

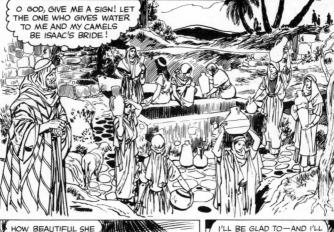

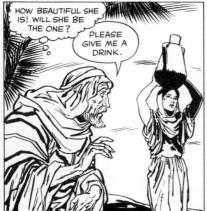

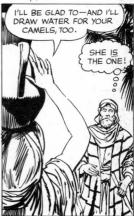

WHEN THE GIRL HAS FINISHED WATERING THE CAMELS, THE SERVANT GIVES HER EARRINGS AND GOLD BRACELETS.

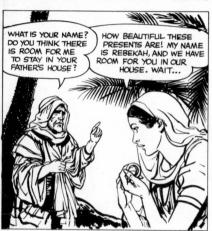

REBEKAH RUNS TO TELL HER FAMILY. WHEN SHE SHOWS THE PRESENTS, LABAN, HER BROTHER, GOES OUT TO MEET ABRAHAM'S SERVANT.

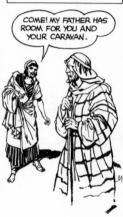

ABRAHAM'S SERVANT TELLS WHO HE IS AND EXPLAINS THAT GOD HAS CHOSEN REBEICAH TO BE THE BRIDE OF ISAAC, SON AND HEIR OF ABRAHAM, HER GREAT UNCLE.

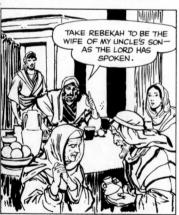

EARLY THE NEXT MORNING, THE CARAVAN GETS READY TO RETURN TO ABRAHAM'S CAMP. REBEICH SAYS GOOD-BY TO HER FAMILY AND THE CARAVAN BEGINS ITS LONG JOURNEY.

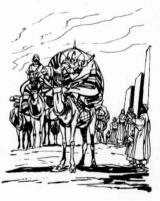

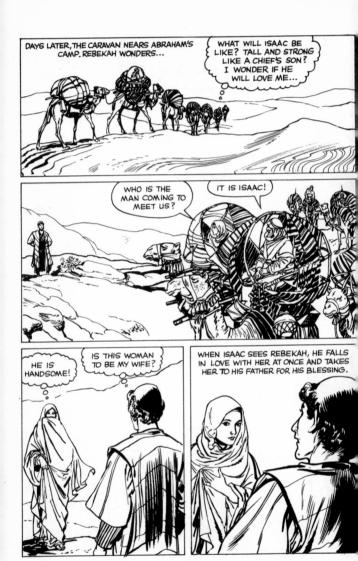

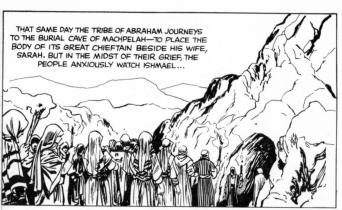

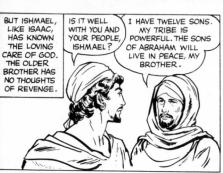

TIME AND AGAIN
GOD HAD TESTED
ABRAHAM'S FAITH...
AND BY FAITH
ABRAHAM HAD OBEYED.
TIME AND AGAIN, TOO,
GOD HAD PROMISED
TO MAKE ABRAHAM
THE FOUNDER OF
GREAT NATIONS...AND
THROLIGH HIS SOMS
THE PROMISE
WAS FULFILLED.

UNDER ISAAC'S PEACEFUL LEADERSHIP, THE TRIBÉ CONTINUES TO GROW. THE PEOPLE ARE LOYAL, EVEN WHEN ISAAC MOVES THEM FROM PLACE TO PLACE TO AVOID WAR WITH NEIGHBORING TRIBES OVER WATER HOLES THAT ARE RIGHTFULLY HIS. BUT ISAAC FAILS TO SEE THE CONFLICT BETWEEN

HIS OWN SONS.

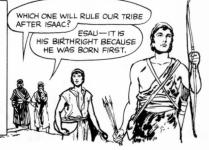

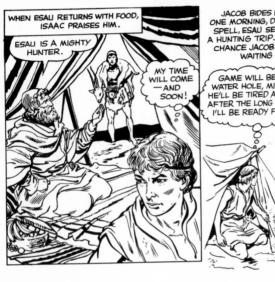

JACOB BIDES HIS TIME ... ONE MORNING, DURING A HOT SPELL, ESAU SETS OUT FOR A HUNTING TRIP ... THIS IS THE CHANCE JACOB HAS BEEN WAITING FOR.

GAME WILL BE AT THE WATER HOLE, MILES AWAY. HE'LL BE TIRED AND HUNGRY AFTER THE LONG DAY'S HUNT.

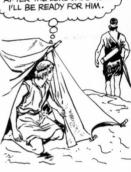

TOWARD SUNDOWN JACOB WAITS FOR HIS BROTHER OUTSIDE CAMP.

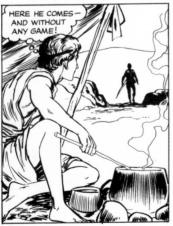

CAMP WITH ITS FOOD IS ONLY A SHORT DISTANCE AWAY, BUT ESAU IS SO HUNGRY HE CANNOT WAIT ...

I'M STARVED ... GIVE ME SOME OF THE STEW.

WILL YOU TRADE YOUR BIRTHRIGHT

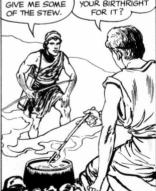

OUR BIBLE IN PICTURES

FROM GENESIS 25: 32-34; 26; 27: 1-41

CRAFTILY, JACOB OFFERS TO TRADE A DISH OF STEW IN RETURN FOR THE BIRTHRIGHT OF HIS OLDER BROTHER, ESAU. ESAU IS HUNGRY... SO HUNGRY HE DOESN'T STOP TO THINK WHAT HE'S DOING...

GÍVE YOU THE RIGHT TO RULE OUR TRIBE SOMEDAY? SURE, YOU CAN HAVE IT!

> HERE IS THE SOUP. NOW, SWEAR THAT THE BIRTHRIGHT IS MINE!

I SWEAR—THE BIRTHRIGHT IS YOURS. NOW, LET ME SIT DOWN AND

EAT.

HERE, EAT ALL YOU WANT.

ESAU'S
BIRTHRIGHT IS
MINE! SOMEDAY
I WILL INHERIT A
DOUBLE PORTION
OF MY FATHER'S
WEALTH! I WILL
RULE THE TRIBE
OF MY FATHER!

R FF AA AA AA BE THI

BUT JACOB HAS A LONG TIME TO WAIT. HIS FATHER IS STILL STRONG AND POWERFUL. WHEN THE PASTURES DRY UP, THE TRIBE MOVES TO BETTER GRASSLANDS NEAR GEARA THERE HE DIGS WELLS—

BUT GIVES THEM UP RATHER THAN FIGHT WITH OTHER SHEPHERDS WHO CLAIM THEM. IN TIME THE KING OF GERAR RECOGNIZES THE STRENGTH AND GOODNESS OF ISAAC, WHO SACRIFICES HIS OWN RIGHTS TO KEEP WARS FROM STARTING. SO THE KING COMES TO ISAAC AND ASKS THAT THE TWO CHIEFTAINS PROMISE ALWAYS TO BE FRIENDS BEFORE AN ALTAR TO GOD, THEY PLEDGE FRIENDSHIP.

EFORE AN ALTAR TO GOD HEY PLEDGE FRIENDSHIP AND SO ISAAC WINS A GREATER VICTORY BY PEACE THAN BY FIGHTING. PEACE-LOVING ISAAC IS NOT AWARE OF THE JEALOUS PLOT THAT IS BUILDING UP IN HIS OWN FAMILY.

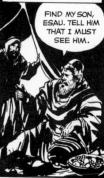

IISAAC HAS GROWN OLD. HIS EYESIGHT IS FAILING. NOW HE DECIDES IT IS TIME TO GIVE HIS ELDEST SON THE BLESSING WHICH WILL INCLUDE RULING THE TRIBE.

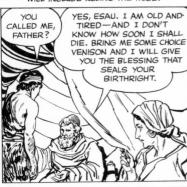

THE NEWS REBEKAH OVERHEARS SENDS HER RUNNING THROUGH THE CAMP...

> FIND JACOB! TELL HIM TO COME TO HIS MOTHER'S TENT-AT ONCE! HURRY!

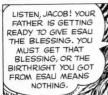

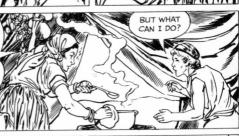

BEFORE YOU AND YOUR BROTHER WERE BORN, THE LORD SPOKE TO ME AND SAID: "THE ELDER SHALL SERVE THE YOUNGER." BUT ESAU WILL SERVE YOU ONLY IF

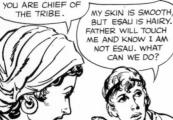

I HAVE THOUGHT OF THAT, TOO. L HERE, PUT ON ESAU'S ROBE - THESE SKINS ON YOUR ARMS AND NECK WILL MAKE YOU FEEL BUT WHAT LIKE ESAU.

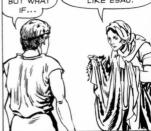

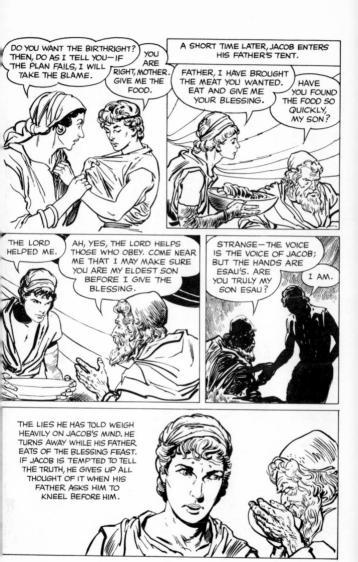

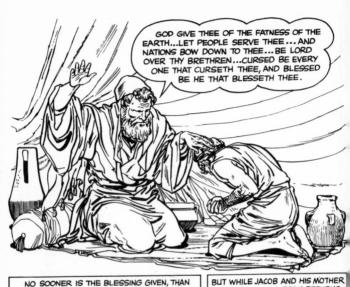

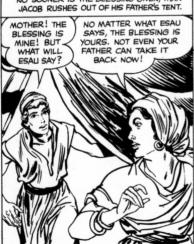

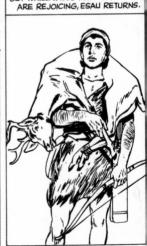

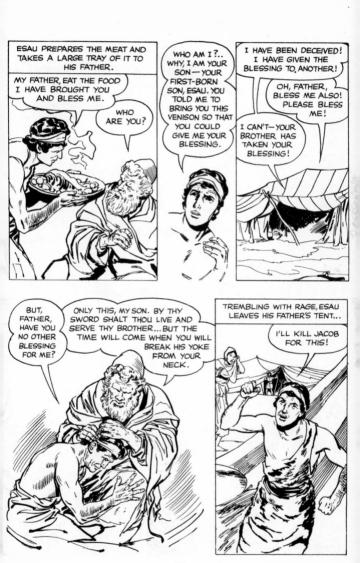

FROM GENESIS 27: 42-46; 28; 29: 1-25

WITH ESAU'S THREAT TO KILL JACOB RINGING IN HER EARS, THE SERVANT GIRL RUNS TO REBEKAH'S TENT.

ESAU 15 GOING TO KILL JACOB! ESAU IS LIPSET—TELL NO ONE WHAT YOU HAVE HEARD. FIND JACOB AND TELL HIM TO COME TO ME

AT ONCE!

TELL MY

FATHER?

ONCE AGAIN, REBEKAH PAVES THE WAY FOR HER FAVORITE SON.

MAMON

ISAAC, ESAU'S WIVES ARE A GREAT TROUBLE TO ME. LIFE WILL NOT BE WORTH LIVING FOR ME IF JACOB MARRIES A WOMAN OF THIS COUNTRY. IF ONLY HE COULD MARRY A GIRL FROM MY PEOPLE — REMEMBER HOW YOUR FATHER'S SERVANT FOUND ME AT MY FATHER'S HOUSE IN HARAN AND BROUGHT ME TO YOU?

ISAAC'S THOUGHTS GO BACK OVER THE YEARS TO THE DAY HE FIRST SAW REBEKAH, HE ALSO KNOWS THERE WILL BE TROUBLE BETWEEN HIS SONS. HE SENDS FOR JACOB.

ASHAMED, BUT FRIGHTENED BY ESAU'S ANGER, JACOB COMES TO HIS FATHER.

GO TO THY MOTHER'S BROTHER. LABAN, AND FIND A WIFE FROM AMONG HIS FAMILY. GOD BLESS

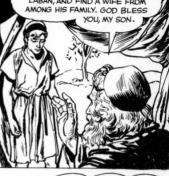

A FEW HOURS LATER-AT THE FOGE OF CAMP ...

GOOD-BY, MY SON. I'LL SEND WORD WHEN IT IS SAFE TO RETURN.

1 Trong

MY FATHER IS OLD - I MAY NEVER SEE HIM AGAIN, ESAU WANTS TO KILL ME. OH, MOTHER, YOU ARE THE ONLY ONE I WILL BE ABLE TO COME BACK TO!

ONE PUNISHMENT FOR THEIR DECEIT IS THAT REBEKAH AND JACOB NEVER SEE EACH OTHER AGAIN.

TRAVELING FARTHER AND FARTHER FROM HIS FAMILY AND FRIENDS, JACOB IS TORTURED BY LONELINESS. HE ESPECIALLY MISSES HIS MOTHER, WHO HAS ALWAYS PROTECTED AND ADVISED HIM. HE IS HAUNTED BY THE MEMORY OF HOW HE TRICKED HIS FATHER AND BROTHER.

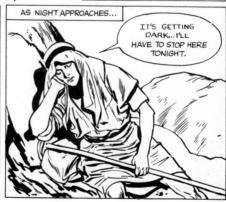

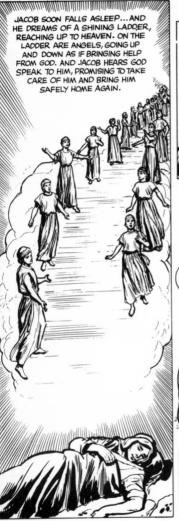

THE NEXT MORNING JACOB AWAKENS, STILL AWED BY THE DREAM HE HAD.

STILL AWED BY THE DREAM HE HALD.

SURELY GOD IS IN THIS PLACE—AND THIS IS THE GATE OF HEAVEN.

JACOB REALIZES THE WRONG HE HAS DONE. BUT HE KNOWS THAT GOD WILL HE HE HE OBEYS HIM. QUICKLY HE TURNS A STONE ON END FOR AN ALTAR AND WORSHIPS GOD. HE CALLS THE PLACE BETH-EL, WHICH MEANS "THE HOUSE OF GOD."

JACOB GOES ON HIS WAY A STRONGER, NOBLER YOUNG MAN BECAUSE HE HAS FOUND GOD. HE IS EAGER TO PUT BEHIND HIM THE DISHONESTY OF HIS PAST AND BECOME REALLY WORTHY OF GOD'S LOVE AND CARE.

QUICKLY HE ROLLS THE STONE FROM THE WELL AND HELPS RACHEL WATER THE SHEEP. WHEN HE TELLS WHO HE IS, SHE RUNS TO TELL HER FATHER.

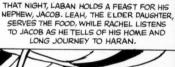

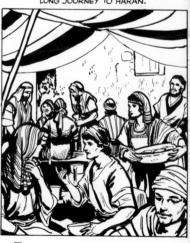

A MONTH LATER, LABAN MAKES A BARGAIN WITH JACOB.

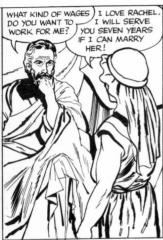

ABAN AGREES.
FOR SEVEN YEARS
JACOB TAKES CARE
OF LABAN'S FLOCKS,
AND BECAUSE
HE LOVES

1

RACHEL, THE YEARS
SEEM BUT A FEW
SWIFT DAYS. THEN
AFTER SEVEN YEARS
JACOB CLAIMS
HIS BRIDE...

I HAVE WORKED SEVEN YEARS FOR YOU, LABAN. NOW GIVE ME RACHEL FOR MY WIFE.

YOU HAVE SERVED ME WELL, JACOB. I'LL ARRANGE THE WEDDING FEAST AT ONCE.

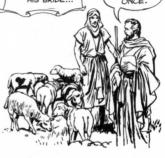

THERE IS MUCH REJOICING, AND AT THE END OF THE WEDDING FEAST, LABAN BRINGS HIS DAUGHTER TO JACOB.

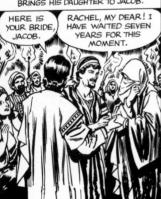

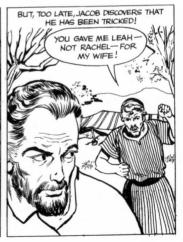

Bargain in the Desert

FROM GENESIS 29: 26-32: 6

JACOB ACCUSES LABAN OF TRICKING HIM INTO MARRIAGE WITH LEAH, INSTEAD OF RACHEL. BUT LABAN ONLY SMILES...

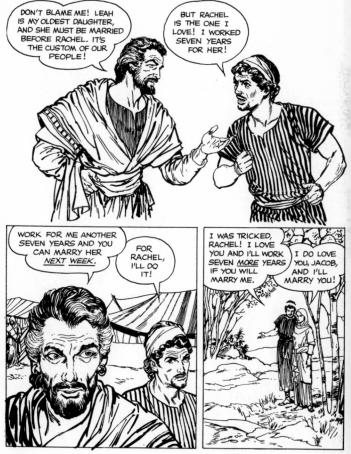

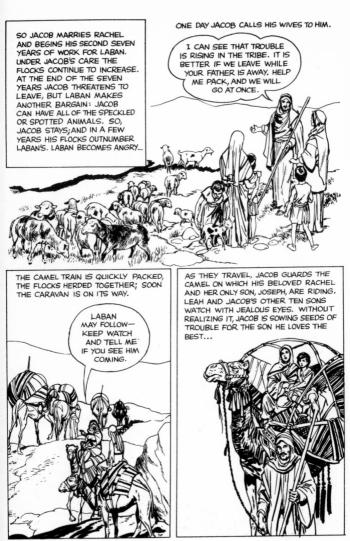

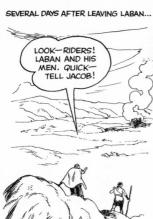

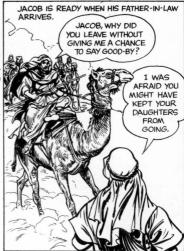

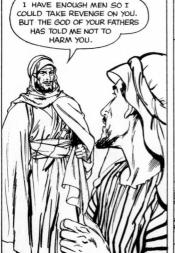

SO LABAN AND JACOB SET UP A HEAP OF STONES AS A MARKER AND MAKE AN AGREEMENT NEVER TO HARM EACH OTHER.

THE LORD WATCH BETWEEN
ME AND THEE, WHEN WE
ARE ABSENT ONE

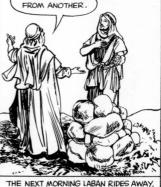

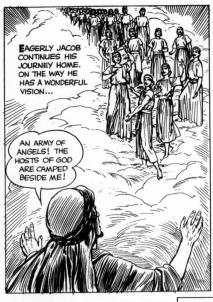

HE IS COMFORTED BY THE ANGELS—BUT AS HE NEARS HIS HOME COUNTRY, HE BEGINS TO WORRY ABOUT HIS BROTHER, ESAU, WHO ONCE PLANNED TO MURDER HIM.

RIDE AHEAD—SEARCH
OUT ESAU. TELL HIM I AM
RETURNING HOME WITH MY
FAMILY AND FLOCKS. TELL
HIM I HOPE HE WILL
FORGIVE ME.

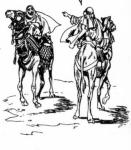

JACOB WAITS ANXIOUSLY FOR THE RIDERS TO COME BACK. HE REMEMBERS THE TIME WHEN HE LIED TO HIS FATHER AND STOLE HIS BROTHER'S BLESSING...WHEN ESAU THREATENED TO KILL HIM...

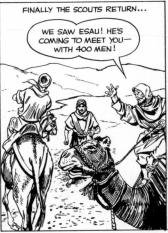

Journey to Hebron

ROM GENESIS 32: 7-33; 35: 1-20

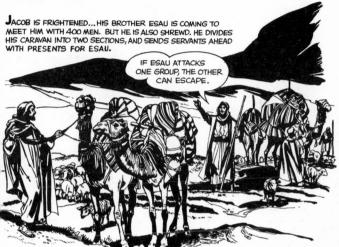

THAT NIGHT JACOB PRAYS—CONFESSING HIS SINS, ADMITTING HIS FEAR, AND ASKING GOD'S HELP. BUT STILL HE CANNOT SLEEP.

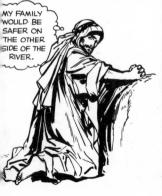

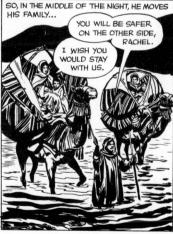

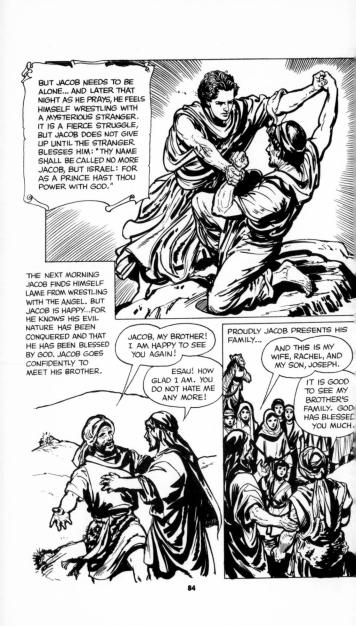

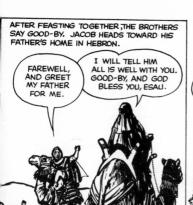

SOME TIME LATER ON THE WAY, JACOB STOPS AT BETH-EL.

THIS STONE, RACHEL, MARKS
THE PLACE WHERE I SAW ANGELS
COMING TO ME FROM HEAVEN,
AND WHERE GOD PROMISED
TO TAKE CARE OF ME. HE
HAS, RACHEL...MORE THAN
I DESERVE.

GOD HAS BEEN
GOOD TO US, JACOB.
AND I PRAY THAT HE
WILL TAKE CARE OF
OUR SON, JOSEPH
AND THE CHILD
WHO IS SOON
TO BE BORN.

FARTHER ALONG ON THE JOURNEY— NOT FAR FROM BETHLEHEM—RACHEL'S CHILD IS BORN...

IT'S A BOY, BUT OH, MY MASTER, YOUR WIFE, RACHEL, IS DEAD! JACOB BURIES HIS BELOVED WIFE, RACHEL. THEN HE AND HIS FAMILY CONTINUE SADLY ON THEIR JOURNEY... STOPPING NOW AND THEN TO REST AND FEED THE FLOCKS. AS THEY TRAVEL ON, JACOB WONDERS...

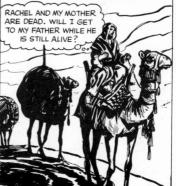

Into the Pit

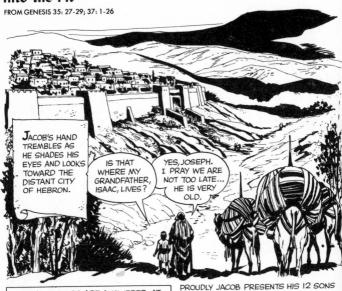

JACOB'S PRAYERS ARE ANSWERED. AT THE SIGHT OF HIS BLIND AND AGED FATHER, HE FALLS TO HIS KNEES.

O FATHER, I AM YOUR SON, JACOB-THANK GOD, I AM WITH YOU JACOB, MY SON! I
HAVE PRAYED FOR
YOUR RETURN. DO
YOU HAVE
CHILDREN NOW?

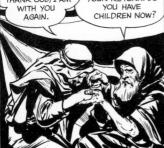

PROUDLY JACOB PRESENTS HIS 12 SONS TO THEIR GRANDFATHER, ISAAC.

FATHER, THESE ARE
JOSEPH AND
BENJAMN, THE SONS
OF MY BELOVED
RACHEL.

BE STRONG,
MY CHILDREN,
AND OBEY
GOD ALWAYS.

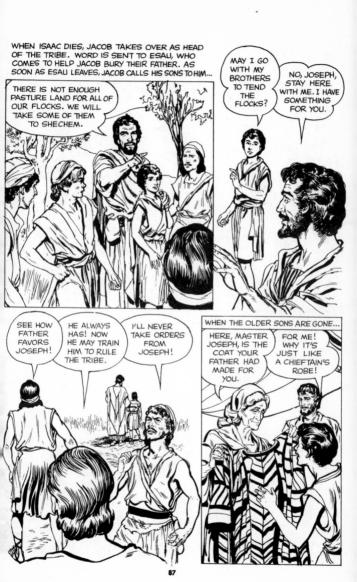

WHEN THE OLDER SONS RETURN, THEY ARE JEALOUS OF JOSEPH'S COAT, THEN HE TELLS THEM ABOUT HIS DREAMS...

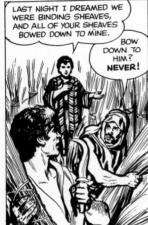

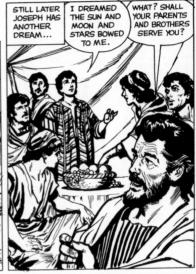

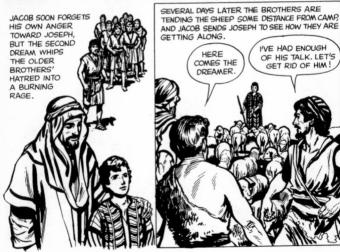

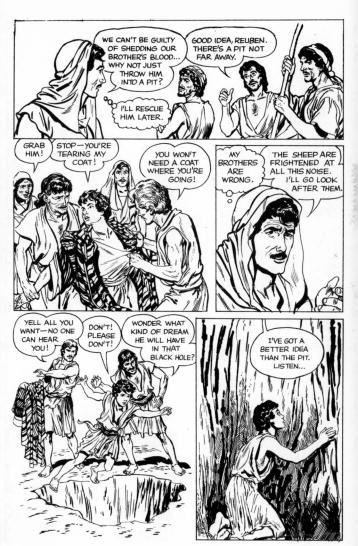

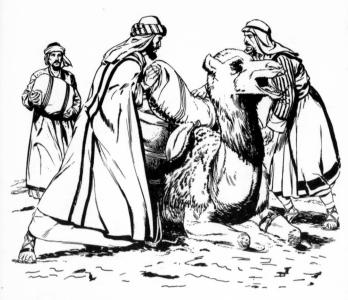

CARAVANS on the TRADE ROUTES

DONG, SLOW CARAVANS CARRYING MERCHANDISE AND TRAVELERS WERE A COMMON SIGHT IN PALESTINE BEFORE, DURING, AND AFTER JESUS' TIME. A WELL-TRAVELED CARAVAN ROUTE FROM BABYLONIA TO EGYPT RAN RIGHT THROUGH PALESTINE.

THE MOST COMMON PACK ANIMALS IN THESE CARAVANS WERE CAMELS BECULSE THEY COULD MAKE THE LONG, HARD JOURNEYS ACROSS THE MOUNTAINS AND DESERTS IN THIS PART OF THE WORLD.

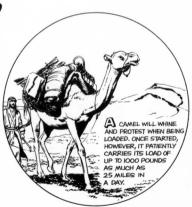

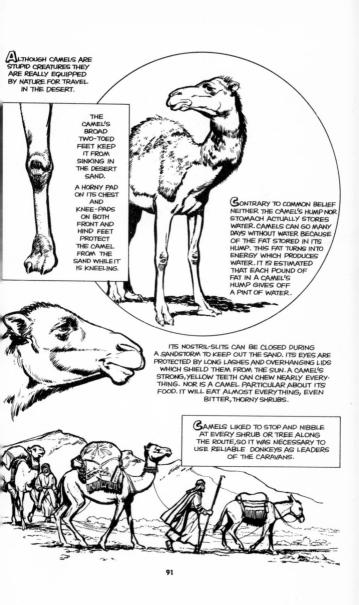

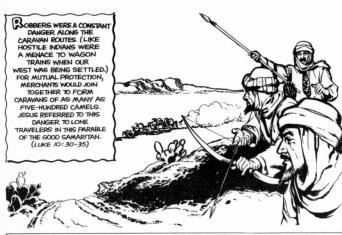

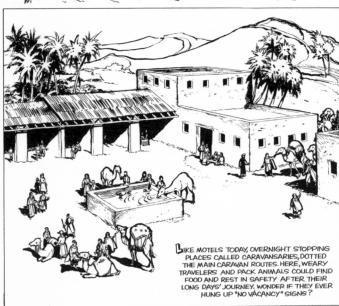

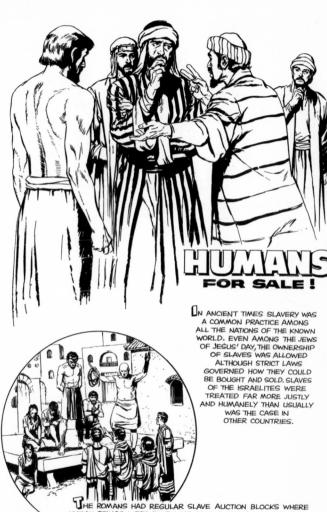

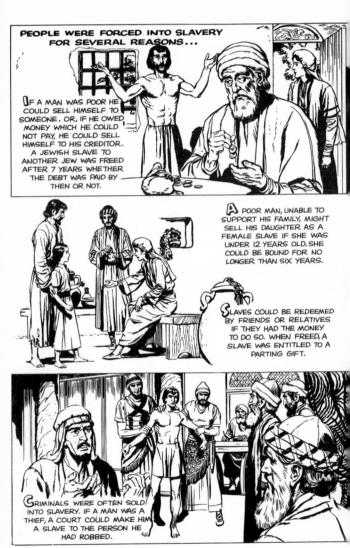

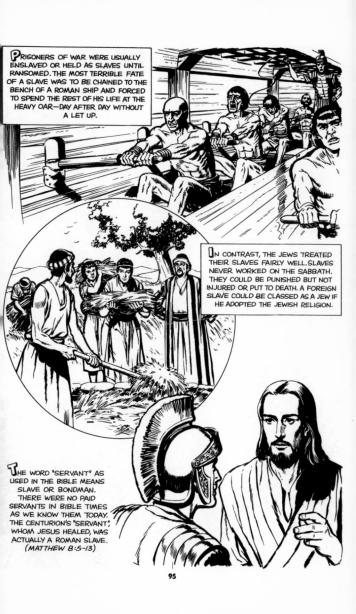

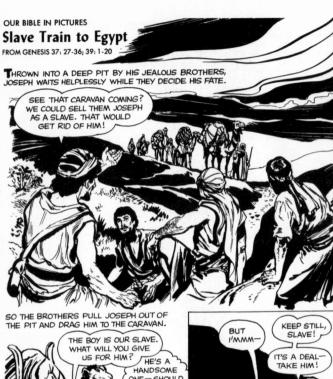

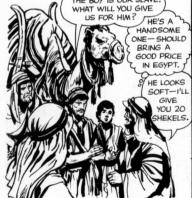

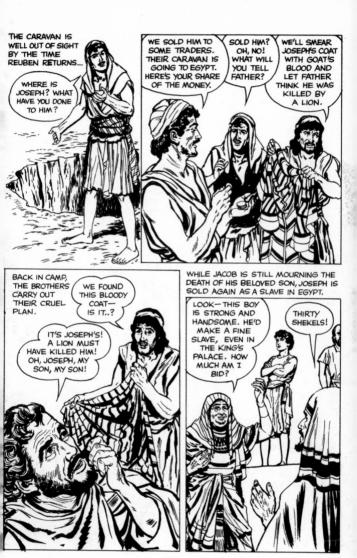

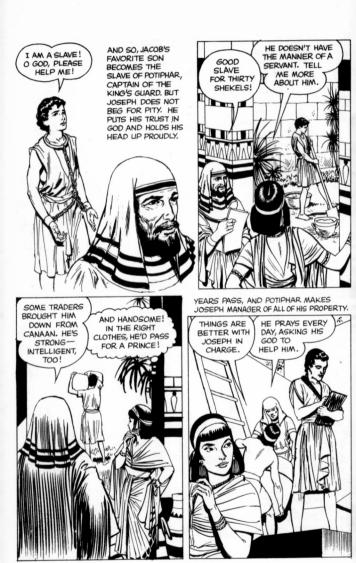

BUT JOSEPH'S SUCCESS ALSO LEADS TO TROUBLE. POTIPHAR'S WIFE FALLS IN LOVE WITH THE HANDSOME, YOUNG SLAVE. ONE DAY WHILE POTIPHAR IS AWAY...

SHE BIDES HER TIME...WHEN POTIPHAR RETURNS SHE GREETS HIM WITH TEARS IN HER EYES, AND A LIE ON HER LIPS.

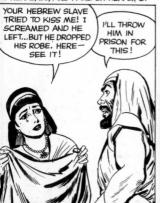

BEFORE THE SUN SETS THAT DAY, JOSEPH IS CHAINED AND THROWN INTO THE KING'S PRISON.

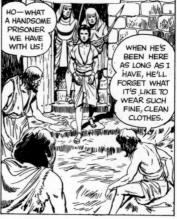

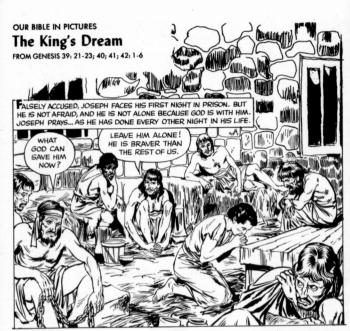

ONE LONG, HOT DAY FOLLOWS ANOTHER. THE PRISONERS QUARREL OVER FOOD —WATER—THE BEST PLACE TO SLEEP. ONE DAY A FIGHT BREAKS OUT...

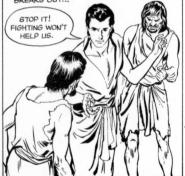

EVEN IN PRISON GOD IS WITH JOSEPH. WHEN THE KEEPER OF THE JAIL LEARNS JOSEPH IS A LEADER, HE PUTS JOSEPH IN CHARGE OF THE OTHER PRISONERS.

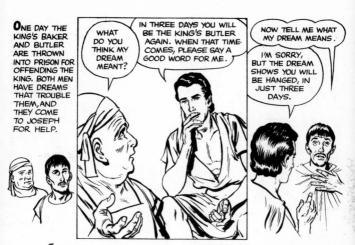

 $oldsymbol{J}$ OSEPH'S WORDS COME TRUE. THREE DAYS LATER, ONE MAN DIES, AND THE OTHER RETURNS TO SERVE THE KING. BUT HE FORGETS HIS PROMISE. TWO YEARS GO BY ...

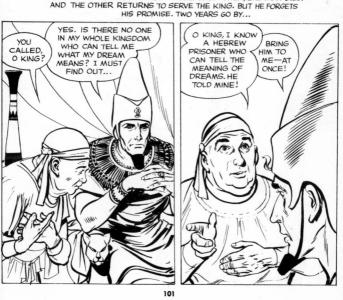

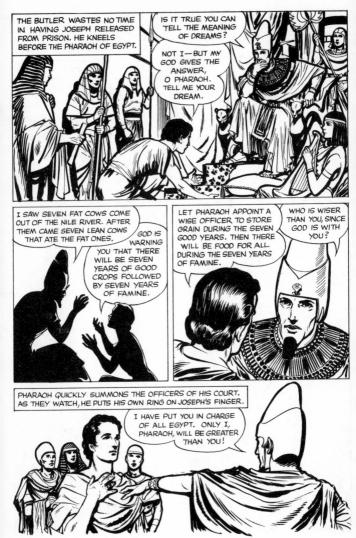

FROM THE THRONE ROOM, JOSEPH GOES TO HIS OWN ROOM AND KNEELS IN PRAYER, THANKING GOD FOR PROTECTION AND GUIDANCE.

JOSEPH ORDERS THE PEOPLE TO START PREPARING FOR THE FAMINE. HE BECOMES FAMOUS, AND ALL REJOICE WHEN HE MARRIES THE BEAUTIFUL DAUGHTER OF THE PRIEST OF ON. I AM PROUD

TO BE YOUR WIFE, JOSEPH. YOU HAVE DONE SO MUCH FOR OUR PEOPLE.

THERE IS MORE TO BE DONE, MY DEAR. THE YEARS OF PLENTY WILL PASS QUICKLY.

ALL TOO SOON, THE FAMINE BEGINS. AS IT CONTINUES, PEOPLE FROM OTHER COUNTRIES COME TO EGYPT SEEKING FOOD, ONE DAY TRIBESMEN FROM CANAAN ENTER JOSEPH'S CITY ...

IN ORDER TO BUY GRAIN, THEY APPEAR BEFORE THE GOVERNOR OF EGYPT. THEY BOW BEFORE HIM ...

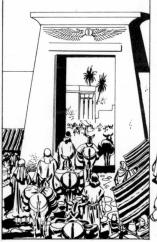

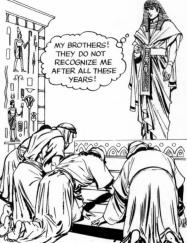

Trouble in Egypt

FROM GENESIS 42: 6-38

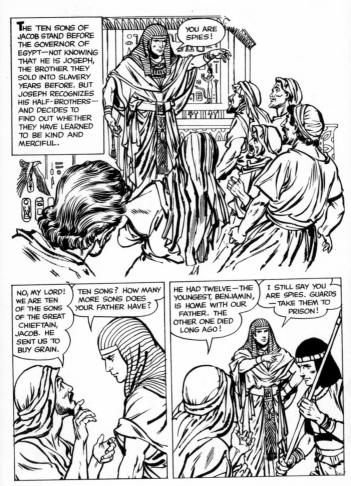

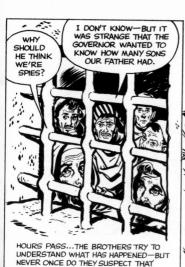

ON THE THIRD DAY THE BROTHERS ARE ONCE MORE BROUGHT BEFORE JOSEPH.

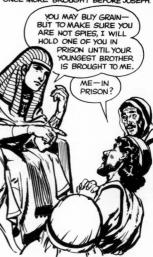

THIS MUST BE PUNISHMENT I TOLD ALL THESE YEARS FOR WHAT WE DID TO JOSEPH LONG AGO.

THIS MUST BE ALL THESE YEARS TO REGRET THE EVIL YOU DID THAT DAY?

THE ONE BROTHER SIMEON IS QUICKLY BOUND AND TAKEN TO PRISON AS A HOSTAGE. FRIGHTENED AND EAGER TO LEAVE EGYPT, THE OTHER BROTHERS HURRY TO THE STOREHOUSE FOR GRAIN.

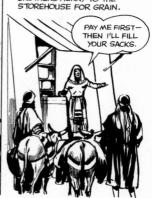

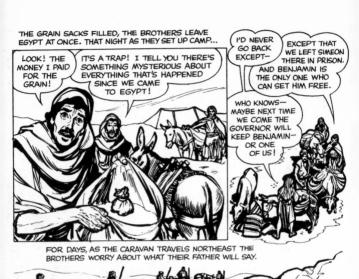

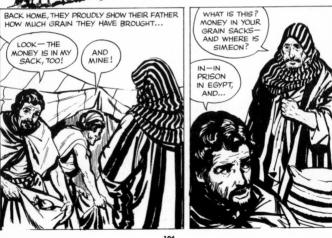

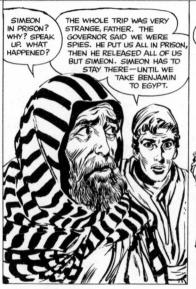

BENJAMIN TO EGYPT? NEVER!
MY SON JOSEPH HAS BEEN DEAD
THESE MANY YEARS—NOW
SIMEON IS LOST TO ME.
I WILL NOT PART WITH
BENJAMIN.
BUT FATHER—
WHAT ABOUT
SIMEON?

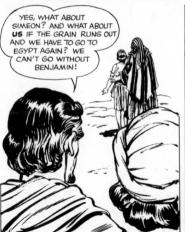

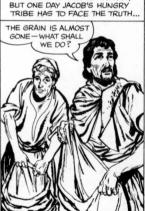

THE GRAIN IS USED SPARINGLY,

The Stolen Cup

FROM GENESIS 43: 1-44: 12

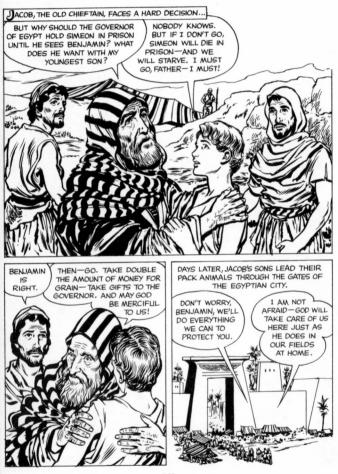

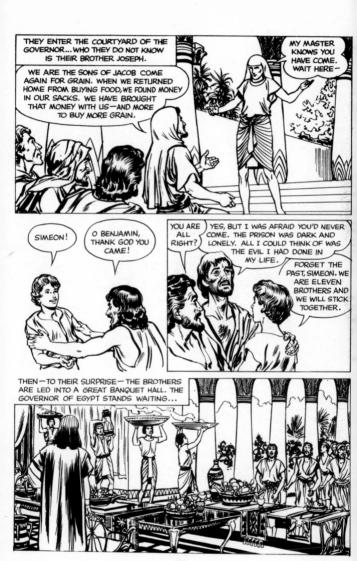

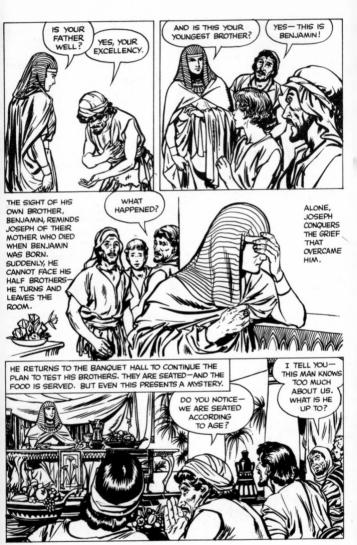

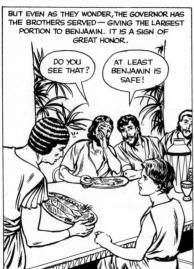

THE BANQUET ENDS; THE NEXT MORNING
THE BROTHERS BUY THEIR GRAIN AND
LEAVE. BUT THEY ARE HARDLY OUT OF
THE CITY BEFORE A
CHARIOT OVERTAKES THEM.

STOP!
ONE OF YOU
HAS STOLEN
MY MASTER'S
SILVER CUP!

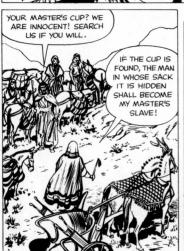

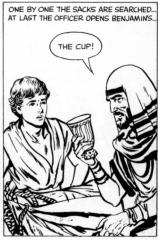

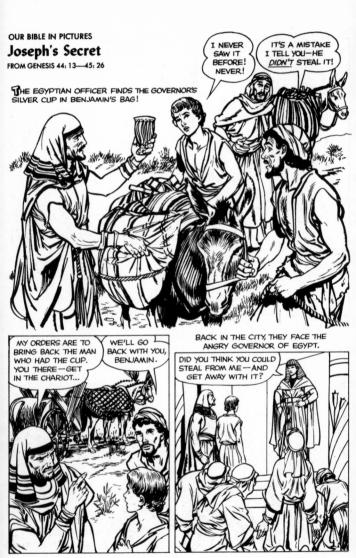

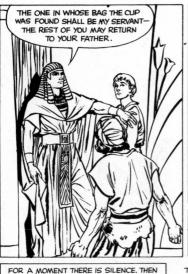

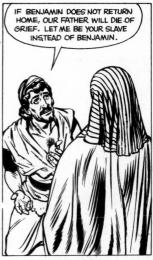

THE GOVERNOR TURNS TO HIS GUARDS.

GO! LEAVE ME ALONE
WITH THESE MEN.

THE FRIGHTENED BROTHERS WAIT. FINALLY JOSEPH SPEAKS ...

I CAN'T KEEP THE SECRET ANY LONGER— I AM YOUR BROTHER, JOSEPH! YOU SOLD ME AS A SLAVE MANY YEARS AGO. GOD HAS BLESSED ME RICHLY...NOW WE ARE TOGETHER AGAIN.

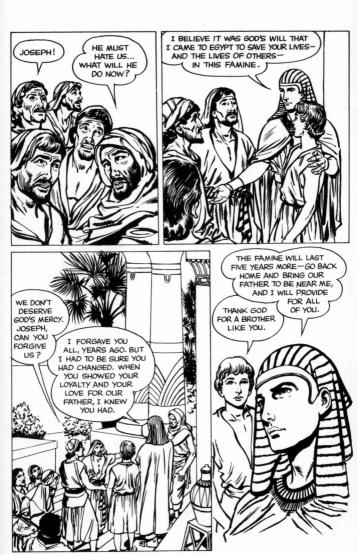

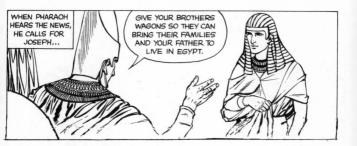

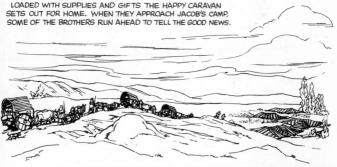

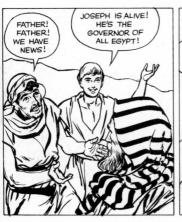

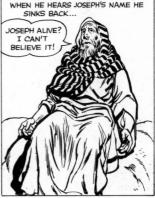

JACOB RISES TO GREET HIS SONS ... BUT

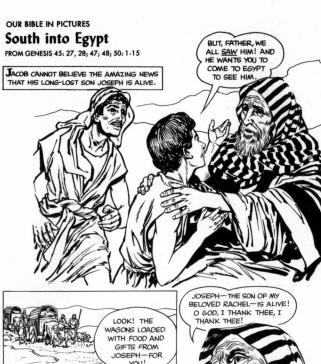

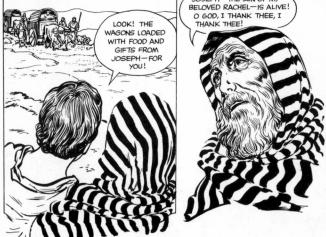

THE EXCITING NEWS SPREADS QUICKLY THROUGHOUT THE CAMP. SOON THE TRIBE OF JACOB BEGINS MOVING SOUTH TOWARD EGYPT. ON THE WAY JACOB STOPS TO WORSHIP AT A PLACE WHERE HE HAD WORSHIPED AS A BOY.

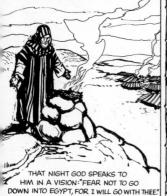

DOWN IN EGYPT, JOSEPH AND HIS FAMILY WAIT ANXIOUSLY!

NOT LIKE PHARAOH, MY SON, BUT HE IS THE CHIEF OF A TRIBE.

PHARAOH?

PHARAOH?

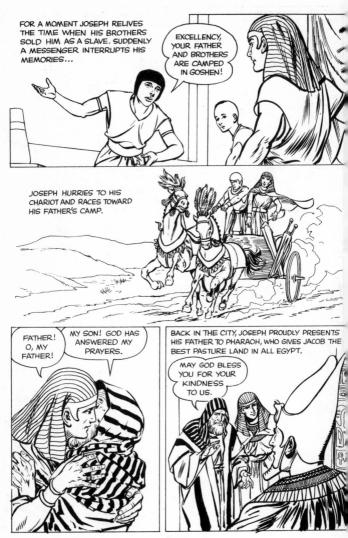

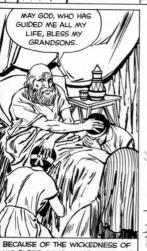

BECAUSE OF THE WICKEDNESS OF HIS OLDER SONS, JACOB GIVES THE FAMILY BIRTHRIGHT TO JOSEPH AND HIS SONS. THEN JACOB CALLS ALL OF HIS SONS TO HIM AND BLESSES THEM. JACOB DIES AND HIS SONS CARRY THE OLD CHIEFTAIN'S BODY BACK TO HIS HOMELAND OF CANAAN.

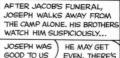

JOSEPH WAS GOOD TO US WHILE OUR FATHER LIVED, BUT NOW...

HE MAY GET EVEN. THERE'S ONLY ONE THING TO DO...

Death Sentence

FROM GENESIS 50: 15-26; EXODUS 1: 1-2: 2

FOLLOWING THE BURIAL OF THEIR FATHER, JOSEPH AND HIS BROTHERS GO BACK TO EGYPT. BUT THE BROTHERS ARE AFRAID THAT JOSEPH MAY NOW TAKE REVENGE FOR THE EVIL THEY DID TO HIM.

YES, OUR FAMILIES ARE THERE.

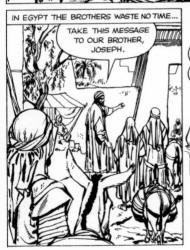

JOSEPH WEEPS WHEN HE HEARS THE WORDS OF THE MESSENGER.

BRING MY BROTHERS TO ME— IS IT POSSIBLE THAT EVEN YET THEY HAVE NOT LEARNED THAT I HAVE FORGIVEN

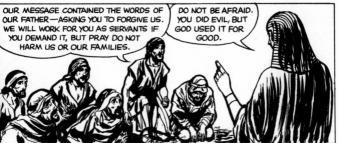

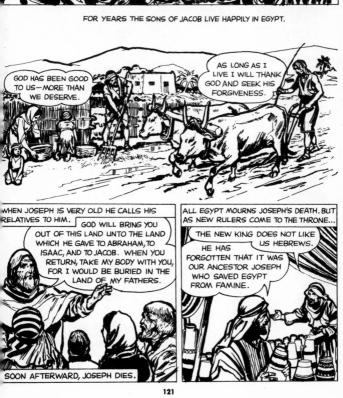

FROM HIS ROYAL YACHT ON THE NILE, THE KING FROWNS AS HE WATCHES THE HEBREW SHEPHERDS WITH THEIR RICH FLOCKS.

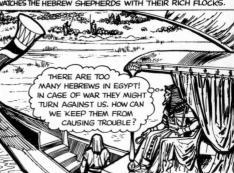

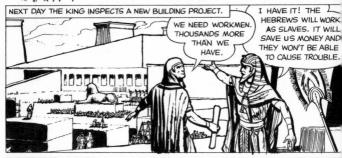

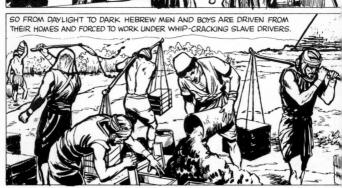

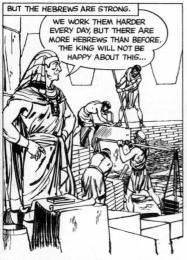

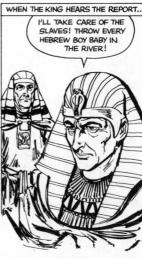

THE CRUEL ORDER IS CARRIED OUT. HEBREW MOTHERS AND FATHERS RISK THEIR LIVES TO PROTECT THEIR SONS...BUT THE KING'S MEN NEVER GIVE UP THEIR SEARCH.

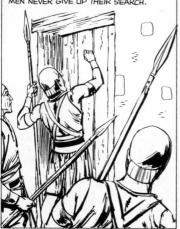

NIGHT AFTER NIGHT ONE HEBREW FATHER HURRIES HOME FROM WORK—AFRAID THAT THE SOLDIERS HAVE VISITED HIS HOME.

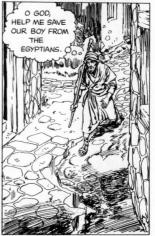

OUR BIBLE IN PICTURES

Cry of a Slave

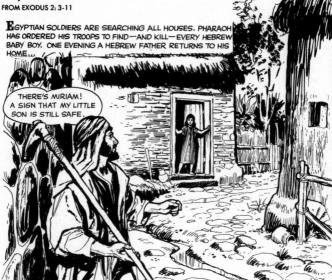

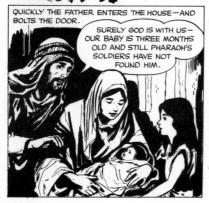

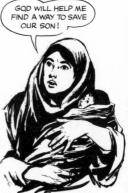

NEXT DAY THE MOTHER SETS ABOUT PREPARING A LITTLE BASKET.

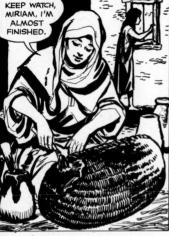

THEN, CAREFULLY AVOIDING THE EGYPTIAN SOLDIERS, SHE TAKES THE BASKET AND HER TINY SON TO THE RIVER.

BROTHER'S KEEP WATCH OVER HIM, BASKET FLOATS LIKE A LITTLE BOAT!

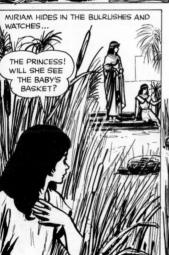

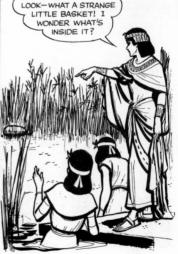

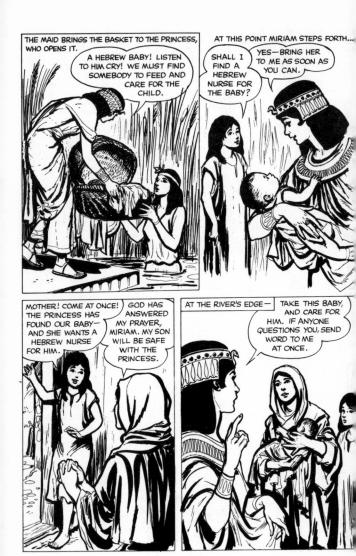

D'THE HEBREW BABY IS RETURNED TO HIS OWN HOME BUT NOW UNDER THE PROTECTION OF THE KING'S NUGHTER. THAT NIGHT THE MOTHER, FATHER, MIRIAM AND YOUNG AARON KNEEL AND PRAY...

O GOD, WE THANK THEE FOR SAVING OUR LITTLE SON, HELP US TO TRAIN HIM TO SERVE THEE! THE LITTLE BOY LIVES IN HIS HOME UNTIL HE IS ABOUT FOUR YEARS OLD. THEN HIS MOTHER TAKES HIM TO THE PALACE TO LIVE WITH THE PRINCESS WHO HAS ADOPTED HIM.

HE WILL BE MY SON. HIS NAME WILL BE MOSE'S BECAUSE THAT IS LIKE THE WORD THAT MEANS "TO DRAW OUT," AND I DREW HIM OUT OF THE WATER.

YEARS PASS, AND THE BOY MOSES LIVES THE LIFE OF A YOUNG PRINCE IN PHARAOH'S PALACE. HE LEARNS TO WRITE AND READ. LATER HE GOES TO COLLEGE. ONE DAY HE

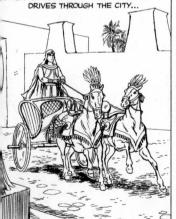

...TO A PLACE WHERE HEBREW SLAVES ARE WORKING. AS HE WATCHES THE SLAVES TOIL, HE IS STARTLED BY A MAN'S SCREAM.

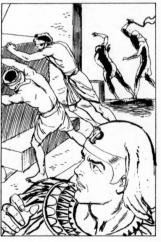

OUR BIBLE IN PICTURES

The Fiery Bush FROM EXODUS 2: 11—3: 4

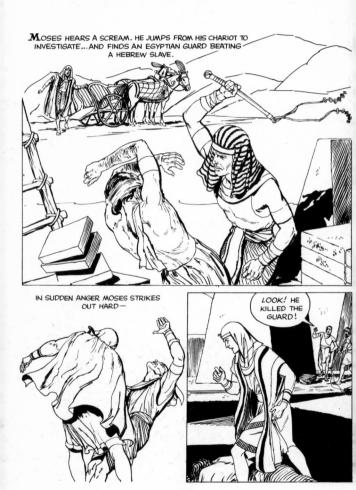

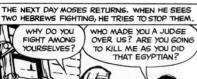

IF PHARAOH HEARS OF THIS HE WILL ACCUSE ME OF BEING A TRAITOR. THERE IS ONLY ONE THING FOR ME TO DO, AND I MUST DO IT NOW...

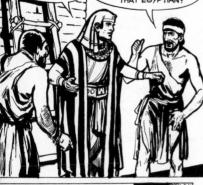

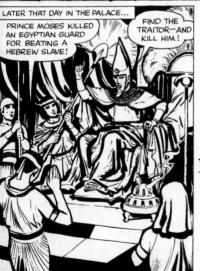

BUT PHARAOH'S ORDERS ARE TOO LATE...MOSES HAS A HEAD START ON THE SOLDIERS WHO CHASE HIM. HE ESCAPES— AND AFTER LONG, HARD RIDING REACHES THE LAND OF MIDIAN.

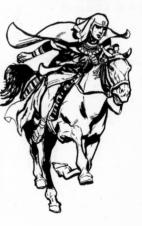

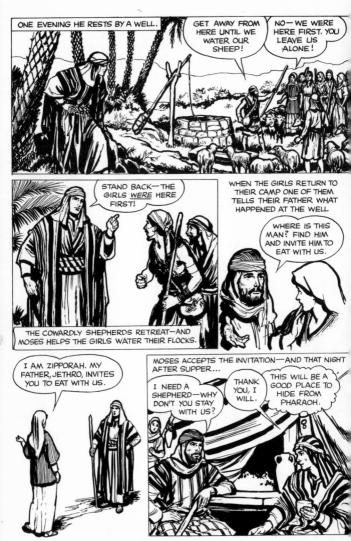

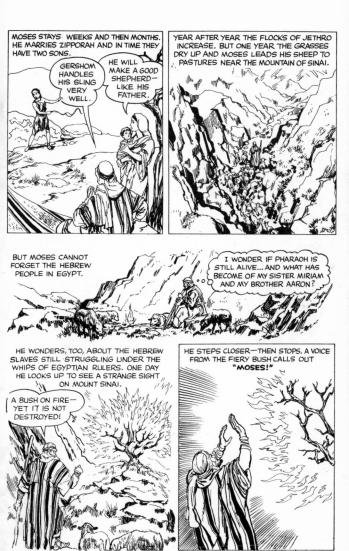

OUR BIBLE IN PICTURES

Pharaoh's Revenge

FROM EXODUS 3: 4-5: 21

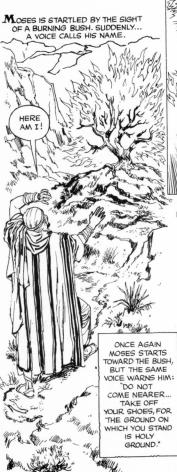

THE VOICE CONTINUES: "I AM THE GOD OF YOUR FATHERS...GO DOWN TO EGYPT, TELL PHARAOH TO SET THE HEBREWS FREE."

MOSES IS AFRAID—AFRAID OF THE PHARAOH OF EGYPT, AFRAID HE CANNOT SPEAK PROPERLY—AFRAID THE HEBREW PEOPLE WILL NOT BELIEVE HIM. BUT GOD ASSURES HIM: "GO—YOUR BROTHER AARON WILL SPEAK FOR YOU. I WILL BE WITH YOU."

MOSES OBEYS. HE RETURNS TO CAMP AND TELLS HIS FATHER-IN-LAW WHAT GOD HAS CALLED HIM TO DO.

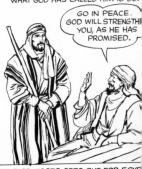

AND SO MOSES SETS OUT FOR EGYP WITH HIS WIFE AND SONS.

MEANTIME...IN THE SLAVE HUTS OF EGYPT, THE HEBREWS ARE ASKING GOD TO HELP THEM

WHILE AARON, THE BROTHER OF MOSES, IS PRAYING, GOD SPEAKS TO HIM: "GO INTO THE WILDERNESS TO MEET YOUR BROTHER."

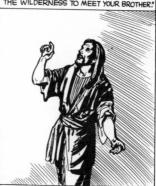

AARON IS SURPRISED AT THE STRANGE COMMAND. BUT, LIKE MOSES, HE OBEYS. SOON HE IS ALONE IN THE WILDERNESS.

MOSES HAS BEEN GONE FROM EGYPT FOR MANY YEARS. WILL HE KNOW ME? DOES HE KNOW I'M COMING? I WONDER WHAT GOD WANTS US TO DO?

AARON'S QUESTIONS ARE SOON ANSWERED.
HE MEETS HIS BROTHER AT MOUNT SINA!

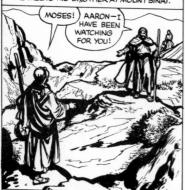

HOW DID YOU KNOW I WAS COMING?

GOD TOLD ME YOU WOULD COME TO HELP ME.

QUICKLY, MOSES EXPLAINS THAT GOD HAS CALLED THEM TO LEAD THE HEBREWS OUT OF SLAVERY IN EGYPT.

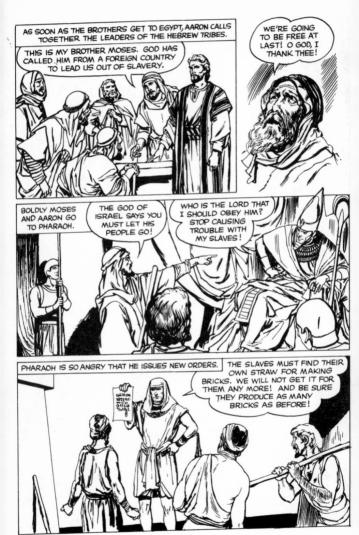

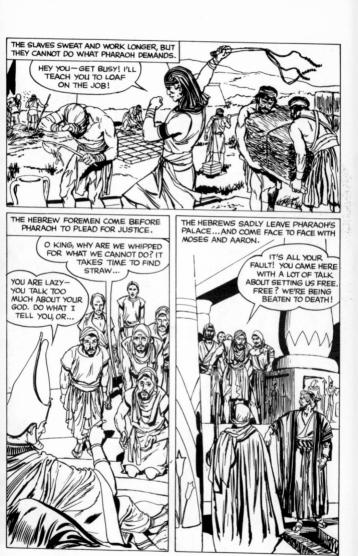

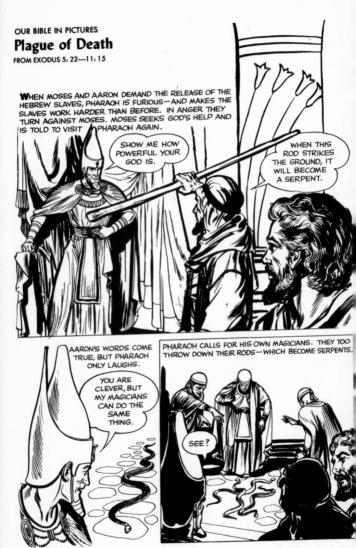

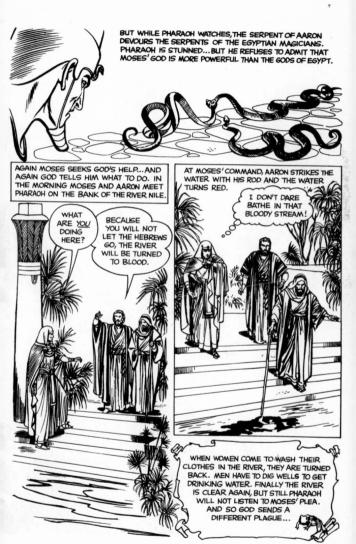

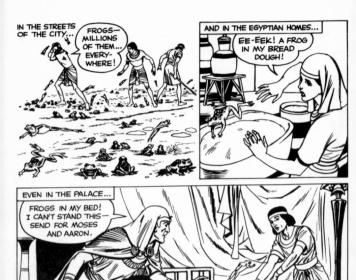

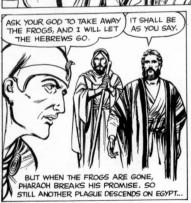

FIRST THERE COMES A PLAGUE OF LICE-LATER GREAT SWARMS OF BITING FLIES

ONCE AGAIN PHARAOH PROMISES TO FREE THE HEBREWS. BUIT WHEN THE FLIES DISAPPEAR, HE BREAKS HIS WORD. THEN DISEASE BREAKS OUT AMONG THE CATTLE, AND PHARAOH AND HIS PEOPLE SUFFER FROM PAINFUL BOILS.

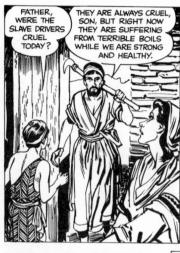

STILL PHARAOH KEEPS THE HEBREWS IN EGYPT. SO A TERRIBLE STORM STRIKES...

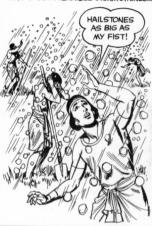

THROUGHOUT THE LAND, THE EGYPTIAN FARMERS WATCH THE STORM WITH TERROR.

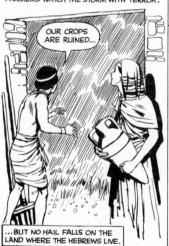

LATER, MILLIONS OF LOCUSTS SWARM THROUGH THE LAND. AFTER A STRONG WIND BLOWS THEM AWAY, THE DAY BECOMES AS DARK AS NIGHT.

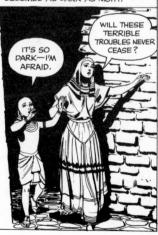

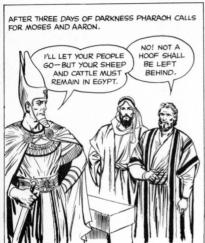

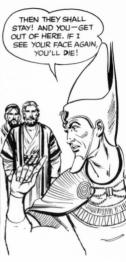

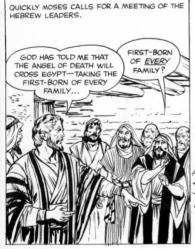

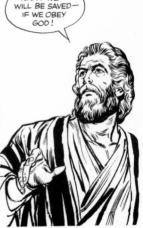

WAIT! WE

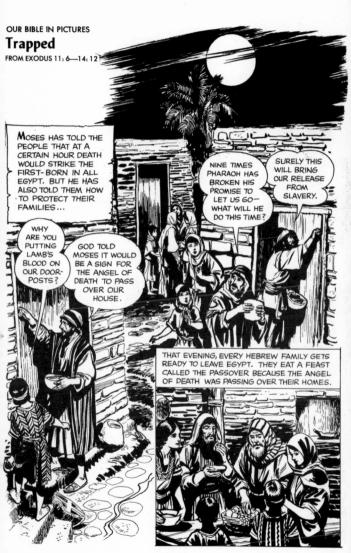

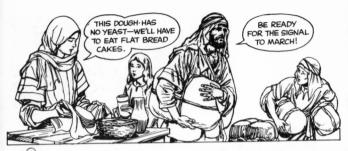

...AND AT MIDNIGHT THE ANGEL OF DEATH STRIKES ALL EGYPT.

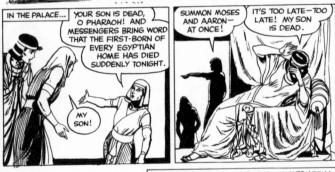

THIS TIME PHARAOH DOES NOT BARGAIN ABOUT CATTLE OR SHEEP.

TAKE YOUR PEOPLE— TAKE YOUR CATTLE AND GET OUT OF EGYPT. SERVE YOUR GOD AS YOU HAVE SAID. THE ORDER TO MARCH IS GIVEN ... IMMEDIATELY THE SLAVES RUSH OUT FROM THEIR SLAVE HUTS, AND MEET AT A CAMP IN THE COUNTRY.

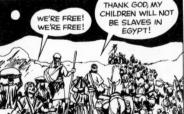

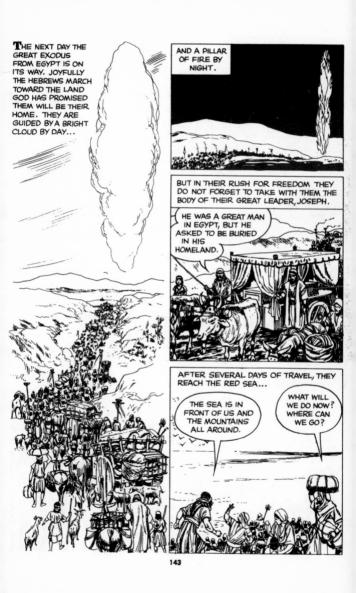

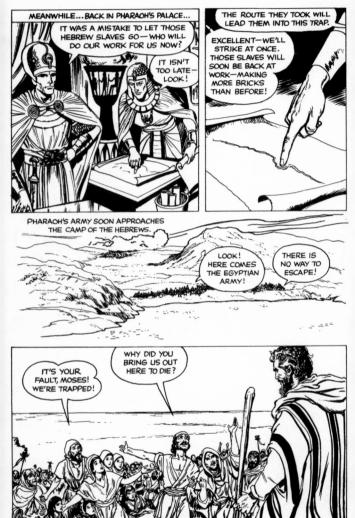

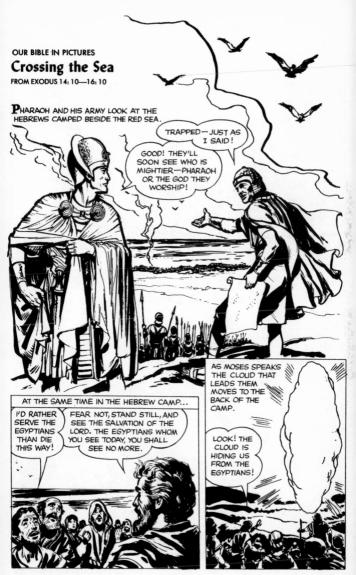

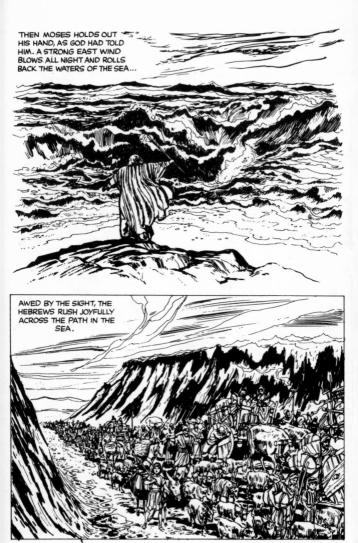

PHARAOH CHARGES. BUT THE HEBREW CAMP IS EMPTY! THE EGYPTIANS RACE OUT ACROSS THE SEA FLOOR, BUT SAND CLOGS THEIR CHARIOT WHEELS ...

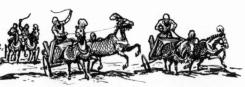

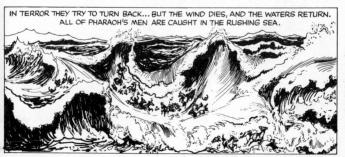

GOD HAS DOUBT THAT MOSES WAS SAVED US! SENT BY GOD TO SAVE US FROM THE EGYPTIANS.

JOYFULLY THE HEBREWS CELEBRATE GOD'S DELIVERANCE, THE TRIBES DESCENDED FROM JACOB (ISRAEL) ARE A FREE PEOPLE-READY TO FORM A NEW NATION. MIRIAM, MOSES'SISTER, LEADS THE WOMEN'S CHORUS SINGING PRAISES SING TO THE

TO GOD. THE LORD IS MY

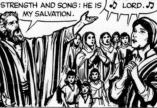

FROM THE RED SEA. THE ISRAELITES MARCH ACROSS THE DESERT. BUT AFTER DAYS OF TRAVEL THEY FORGET WHAT GOD HAS DONE FOR THEM. AND THEY BEGIN TO COMPLAIN ...

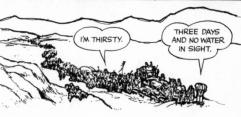

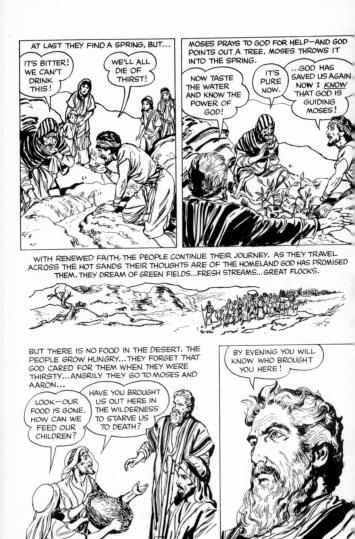

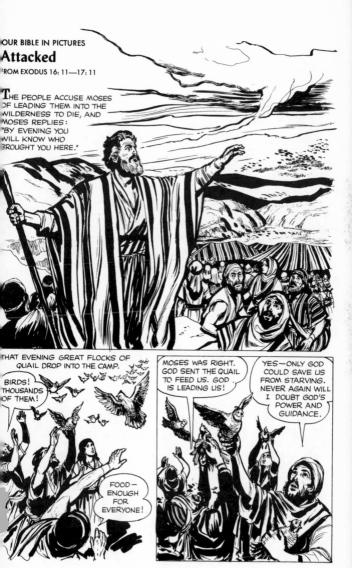

EARLY THE NEXT MORNING THE PEOPLE ARE SURPRISED TO FIND A STRANGE WHITISH COVERING ON THE GROUND.

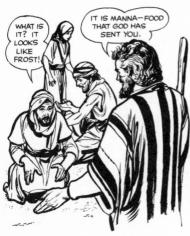

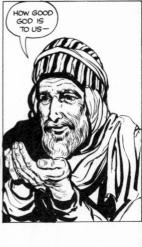

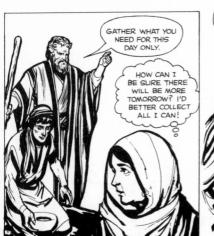

SEE—I'LL PUT THIS EXTRA
ASIDE FOR TOMORROW. NO
MATTER WHAT HAPPENS TO
THE OTHERS, WE WILL
NOT GO HUNGRY.

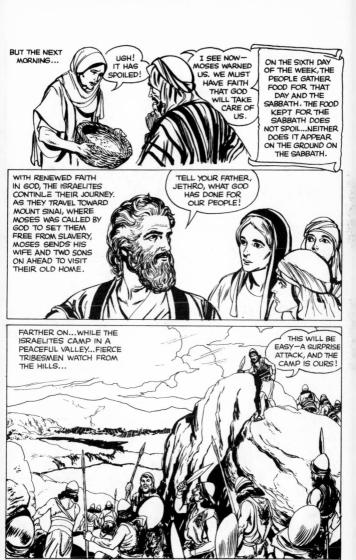

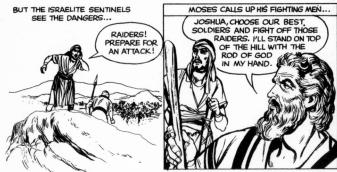

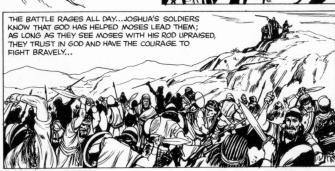

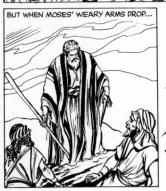

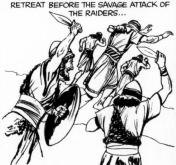

THE ISRAELITE SOLDIERS ARE AFRAID...AND

OUR BIBLE IN PICTURES

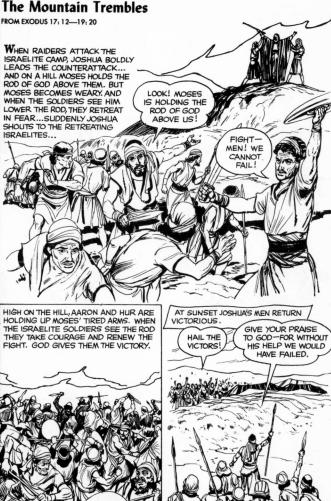

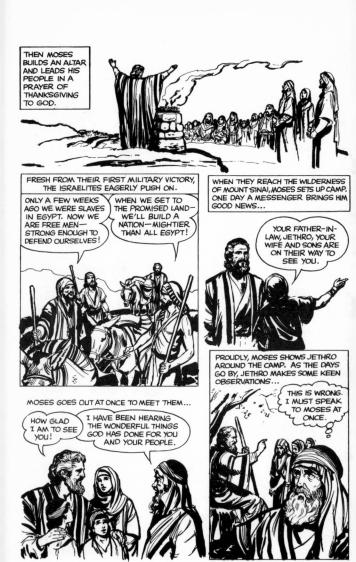

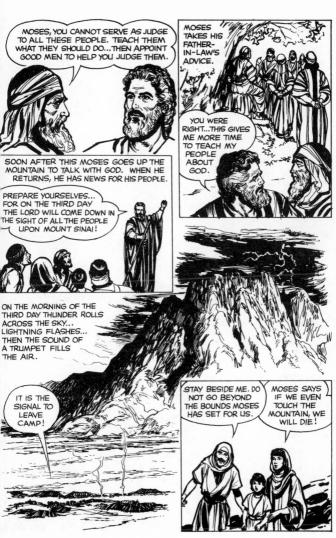

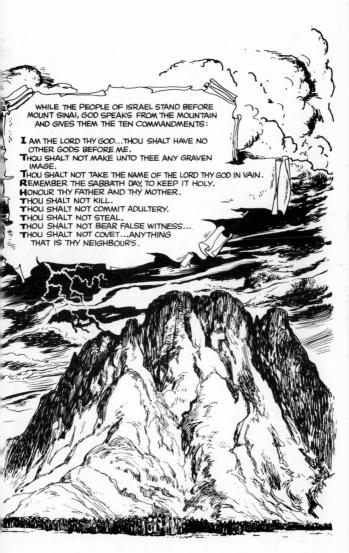

THE PARTY OF THE P

FOR ALL AGES

Do you have ALL SIX books?

Vol. 1—CREATION: Gen. 1 to Ex. 19. All the action from "In the beginning" to the Flight . . . in pictures!

Vol. 2—PROMISED LAND: Ex. 20 to I Sam. 16. Moses, Ten Commandments, wanderings, fall of Jericho.

Vol. 3—KINGS AND PROPHETS: I Sam. 16 to I Kings 21. Shows David and Goliath, wisdom of Solomon.

Vol. 4—THE CAPTIVI-TY: I Kings 21 to Mal. Covers the Babylonian captivity, prophecies of Jesus' coming.

Vol. 5—JESUS: Mt. to John. Dramatically shows the birth, teaching, miracles, final triumph of Christ.

(Cont.)

The set of

Those who know the Bible will love the pictures; those who see the pictures will love the Bible!

Sub-total \$

Handling

TOTAL \$

is a much-appreciated gift

Vol. 6—THE CHURCH: Acts to Rev., with a special section tracing the history of the modern Bible.

You can order these books from your local bookstore, or from the David C. Cook Publishing Co., Elgin, IL 60120 (in Canada: Weston, Ont. M9L 1T4).

---Use This Coupon----

Address —				
ITEM State	ZIP Code			
	STOCK NO.	PRICE	QTY.	ITEM TOTAL
/ol. 1—CREATION	73080	95∉		\$
/ol. 2—PROMISED LAND	73098	95¢	1.5	
/ol. 3—KINGS AND PROPHETS	73106	95¢		
Vol. 4—THE CAPTIVITY	73114	95¢		
/ol. 5—JESUS	73122	95¢	· E	
/ol. 6—THE CHURCH	73130	95¢		
ET OF ALL SIX	73262	\$4.95		

IOTE: On orders placed with David C.

Cook Publishing Co., add handling charge of 25¢ for first dollar, plus 5¢ for each additional dollar.